Cloud
Sketching

Creative Drawing for Cloud Spotters and Daydreamers

Cloud Sketching

MARTÍN FEIJOÓ

QUARRY

Quarto is the authority on a wide range of topics.

Quarto educates, entertains and enriches the lives of our readers—enthusiasts and lovers of hands-on living.

www.QuartoKnows.com

FIRST PUBLISHED IN THE UNITED STATES OF AMERICA IN 2016 BY
QUARRY BOOKS, AN IMPRINT OF
QUARTO PUBLISHING GROUP USA INC.
100 CUMMINGS CENTER
SUITE 406-L
BEVERLY, MASSACHUSETTS 01915-6101
TELEPHONE: (978) 282-9590
FAX: (978) 283-2742
QUARTOKNOWS.COM
VISIT OUR BLOGS AT QUARTOKNOWS.COM

10 9 8 7 6 5 4 3 2 1

ISBN: 978-1-63159-095-5

DIGITAL EDITION PUBLISHED IN 2016
EISBN: 978-1-62788-853-0

LIBRARY OF CONGRESS CATALOGING-IN-PUBLICATION DATA

FEIJOÓ, MARTÍN, 1981-2015, AUTHOR, ILLUSTRATOR.
 CLOUD SKETCHING : CREATIVE DRAWING FOR CLOUD SPOTTERS AND
DAYDREAMERS
 / MARTIN FEIJOÓ.
 PAGES CM
 ISBN 978-1-63159-095-5 (PAPERBACK)
 1. CLOUDS IN ART. 2. DRAWING—TECHNIQUE. 3. FEIJOÓ, MARTÍN,
1981-2015-
 THEMES, MOTIVES. 1. TITLE.
 NC825.C585F45 2016
 751.42'2—DC23

 2015034978

DESIGN: KATHIE ALEXANDER
PHOTOGRAPHY: ALL PHOTOGRAPHY BY MARTÍN DIEGO FEIJOÓ GÓMEZ,
WITH THE EXCEPTION OF THE FOLLOWING PAGES: 110—111, 115, 118,
120, 121, 123, 126, 131, 132, 135, 136—137, 138, 142, 146, 147.

PRINTED IN CHINA

For daydreamers everywhere

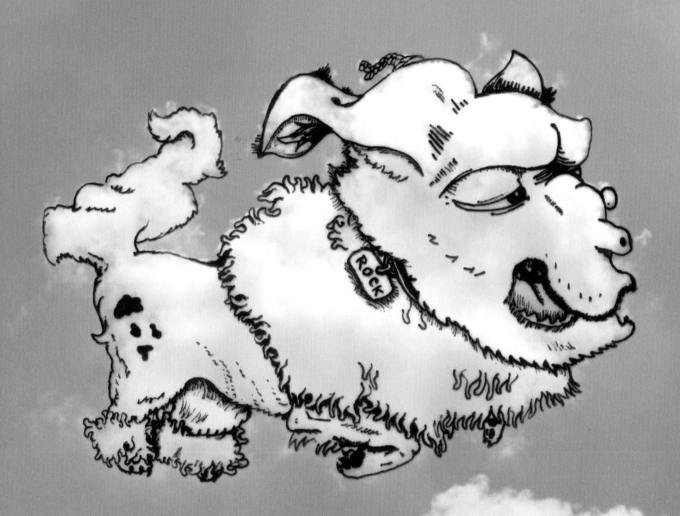

CONTENTS

INTRODUCTION

I COULD SAY THAT THIS IDEA OF SHAPING CLOUDS AND TURNING THEM INTO ILLUSTRATIONS STARTED WHEN I WAS A CHILD, BUT THE TRUTH IS THAT THE IDEA OF THIS PROJECT CAME TO ME DURING ONE PARTICULAR HOLIDAY IN MEXICO. THERE, I NOTICED THAT THE CLOUDS WERE MUCH MORE SHAPELY THAN THE ONES I WAS USED TO SEEING IN MADRID EVERY DAY.

I STARTED TO CARRY MY CAMERA WITH ME CONSTANTLY, AND, EVERY TIME I HAD THE CHANCE, I STARTED PHOTOGRAPHING ALL THE CLOUDS THAT CAUGHT MY EYE. EVEN WHEN I PHOTOGRAPHED MY FRIENDS WITH A BEAUTIFUL BACKGROUND, CLOUDS WERE THERE, DRAWING MY ATTENTION.

I KNEW THAT I WAS NOT THE FIRST PERSON IN THE WORLD TO HAVE THIS IDEA OF SKETCHING CLOUDS. BUT IF I WAS GOING TO DO SOMETHING WITH CLOUDS, I NEEDED IT TO BE SOMETHING COOL, NOT JUST PHOTOGRAPHING THEM.

THEN, OUT OF THE BLUE, I REMEMBERED A STORY I WAS TOLD AS A CHILD, THAT CLOUD SHAPES WERE ORIGINALLY MADE BY A GROUP OF EXPERT BALLOON-TWISTING CLOWNS WHO LIVE IN THE SKY, AND THAT STORY "CLICKED" IN MY MIND. SUDDENLY, EVERYTHING MADE SENSE: I HAD TO USE MY DRAWING SKILLS TO TURN THOSE CLOUD SHAPES INTO ILLUSTRATIONS AND USE THOSE CLOUD SKETCHES TO CREATE A BEAUTIFUL PROJECT!

Recognizing Good Clouds

DO'S AND DON'TS OF CLOUD HUNTING

THERE ARE NO RULES FOR FINDING AND RECOGNIZING GOOD CLOUDS. I'M SURE THAT IF, ONE DAY, YOU DECIDE TO GO OUT AND LOOK FOR SOME, YOU'LL DEVELOP YOUR OWN TECHNIQUE. THE REASON I'D LIKE TO SHARE THESE FEW THINGS WITH YOU THAT I'VE LEARNED WHILE WORKING ON THIS PROJECT IS TO PREVENT YOU FROM MAKING THE SAME MISTAKES I DID.

1 ALWAYS HAVE YOUR CAMERA, ALWAYS.

IF YOU'VE FINALLY DECIDED TO LOOK FOR SOME CLOUDS, MAKE SURE YOU'VE SET UP YOUR CAMERA THE RIGHT WAY AND YOU HAVE A FULLY CHARGED BATTERY BEFORE YOU DO. KEEP YOUR CAMERA ON ALL THE TIME IF YOU CAN, BECAUSE ONE SECOND CAN MAKE THE DIFFERENCE BETWEEN A GOOD AND A BAD PHOTOGRAPH OF A CLOUD.

2 THE WIND IS BOTH YOUR ENEMY AND YOUR ALLY.

WIND CAN BE A USEFUL TOOL SOMETIMES, ESPECIALLY WHEN IT'S GIVING SOME GREAT SHAPES TO CLOUDS. ON THE OTHER HAND, TOO MUCH WIND CAN ALSO BE A PROBLEM BECAUSE SHAPES DON'T LAST. IT'S ESSENTIAL TO BE QUICK: IF CLOUDS CHANGE FAST, YOU SHOULD MOVE FASTER.

3 MIDDAY IS THE BEST TIME OF THE DAY.

DURING ALL THIS TIME PHOTOGRAPHING CLOUDS, I'VE LEARNED THAT THE PERFECT TIME TO GO "CLOUD HUNTING" IS WHEN THE SUN IS RIGHT ABOVE THEM. WHEN THE SUN IS IN THAT POSITION, YOU CAN MAKE THE MOST OF A CLOUD'S LIGHTS AND SHADES, WHICH WILL BE VERY HELPFUL THE NEXT TIME YOU SIT DOWN AND START TURNING THOSE CLOUDS INTO ILLUSTRATIONS. I'VE PHOTOGRAPHED CLOUDS EARLY IN THE MORNING AND ALSO AT DUSK, AND THE COLORS OF THOSE CLOUDS ARE NOT USEFUL (UNLESS YOU FIND A CLOUD WITH THE SHAPE OF A LOBSTER, OF COURSE).

THE BEST CLOUDS WON'T BE WAITING FOR YOU AT YOUR FRONT DOOR.

MANY OF US LIVE IN THE CITY, AND WHETHER WE LIKE IT OR NOT, WE'RE SURROUNDED BY ALL KINDS OF BUILDINGS THAT WON'T LET US HAVE A 360-DEGREE VIEW OF THE SKY, WHICH IS SOMETHING WE NEED IF WE'RE PLANNING TO HUNT CLOUDS. ANOTHER PROBLEM IS AIR POLLUTION, WHICH CAN AFFECT THE WAY WE SEE CLOUDS. GOING OUT TO LOOK FOR SOME GREAT CLOUDS IS THE PERFECT EXCUSE TO LEAVE YOUR PLACE FOR A FEW HOURS AND GO SOMEWHERE NICE OUTSIDE THE CITY: YOU'LL NOT ONLY BE BREATHING FRESHER AIR BUT ALSO ENJOYING NEW VIEWS AND HAVING A GREAT TIME. IF YOU DON'T KNOW WHERE TO GO, JUST DRIVE AWAY; I FOUND A LOT OF INSPIRATION WHILE ON THE ROAD. SOMETIMES, BEING IN THE MIDDLE OF NOWHERE IS THE PERFECT PLACE TO BE.

> *"Why do I love clouds? Because you can't save a cloud like you can save a leaf or a flower or a rock—clouds are now."*
>
> TERRI GUILLEMETS

5 UNLEASH YOUR IMAGINATION.

WHEN YOU'RE SHAPING CLOUDS, YOU'RE GIVING YOUR MIND A BREAK. YOU'LL FIND YOURSELF NOT THINKING ABOUT YOUR OBLIGATIONS OR THE APPOINTMENTS ON YOUR AGENDA. YOUR ONLY CONCERN WILL BE TO FIND THE PERFECT CLOUDS AND TO LET YOUR IMAGINATION HAVE FUN WITH THEM. I CAN ASSURE YOU THAT, WITHOUT EVEN NOTICING IT, YOU WILL RELEASE YOUR INNER CHILD AGAIN DURING THOSE MAGICAL MOMENTS.

6

CLOUDS ARE MORE USEFUL ABOVE YOU THAN BESIDE YOU.

I GUESS THAT THIS IS SOMETHING THAT DEPENDS ON WHERE YOU LIVE OR WHERE YOU ARE AT THE TIME YOU START PHOTOGRAPHING CLOUDS. I'VE BEEN ON A FEW ROOFTOPS TAKING PHOTOS OF CLOUDS, AND THE RESULTS ARE NOT THE SAME AS WHEN I PHOTOGRAPH CLOUDS AT STREET LEVEL. I CAME TO REALIZE THAT ONLY WHEN YOU'RE RIGHT BELOW A CLOUD CAN YOU FULLY APPRECIATE ITS SHAPE AND MAKE THE MOST OF IT.

DON'T TAKE JUST ONE PHOTO—TAKE A THOUSAND!

A LOT OF THE TIME WHEN I WAS LOOKING AT A CLOUD AND THINKING, "WELL, THAT'S A GREAT CLOUD," I TOOK JUST ONE PHOTOGRAPH OF IT. BUT THEN, BACK HOME, I REALIZED THAT THE CLOUD I PHOTOGRAPHED DIDN'T HAVE THE SHAPE I REMEMBERED, AND ALL THE TIME I SPENT WAS FOR NOTHING. WHEN YOU SEE ONE CLOUD OR A GROUP OF THEM, TAKE A LOT OF PHOTOGRAPHS. EVEN IF YOU END UP USING ONLY ONE OUT OF TEN, THE ONE GOOD PHOTOGRAPH WILL BE WORTH ALL THE TIME YOU SPENT GETTING IT.

ALWAYS KEEP YOUR MIND OPEN.

TRY TO REMEMBER WHATEVER CAME INTO YOUR MIND WHEN YOU PHOTOGRAPHED A CLOUD, BUT DON'T FORCE YOURSELF TO DRAW IF YOU HAVE NEW IDEAS. IT HAPPENS TO ME A LOT: THE SECOND TIME I LOOK AT A CLOUD I PHOTOGRAPHED, I FIND NEW CREATURES HIDDEN IN ITS SHAPE. IMAGINATION IS LIKE A RIVER THAT MUST ALWAYS FLOW, SO DON'T STOP IT—YOU MIGHT BE SURPRISED BY ALL THE IDEAS THAT COME TO YOUR MIND WHEN YOU'RE LOOKING AT A CLOUD.

 EMBRACE THE RAIN (AT LEAST BEFORE AND AFTER).

RAINY DAYS HAVE BECOME MY FAVORITE DAYS THANKS TO THIS PROJECT. THE MINUTES BEFORE AND AFTER RAIN ARE A SOURCE OF GREAT CLOUDS YOU CAN'T MISS. EVERY TIME I SEE THAT RAIN IS COMING, I GO OUT AND FEEL THE MOISTURE IN THE AIR (WHICH IS SOMETHING I LOVE). WHILE I SEE THE WAY CLOUDS ARE GATHERING, BEFORE PRECIPITATION FALLS, I START LOOKING FOR CLOUDS I CAN USE AND PHOTOGRAPH.

ONCE THE RAIN STOPS FALLING, CLOUDS WILL START DISSIPATING, AND THAT'S ANOTHER PERFECT TIME FOR LOOKING FOR SHAPES IN CLOUDS. TAKE AS MANY PHOTOGRAPHS AS YOU CAN BEFORE THE CLOUDS ARE GONE, BECAUSE ONCE THE SKY IS COMPLETELY CLEAR AGAIN, YOU WON'T SEE CLOUDS LIKE THOSE UNTIL THE NEXT RAINY DAY.

 FORGET HUNTING CLOUDS AT NIGHT.

UNLESS YOU OWN A PROFESSIONAL CAMERA WITH SOME KIND OF AMAZING NIGHT VISION OR AN APPLICATION THAT DOESN'T NEED LIGHT TO TAKE A GOOD PHOTOGRAPH OF A CLOUD, DON'T WASTE YOUR TIME TRYING TO TAKE A PICTURE OF NIGHT CLOUDS. THEY ONLY LOOK GOOD IN THE SKY.

DO YOU REALLY THINK THAT YOU HAVE A PROFESSIONAL CAMERA THAT CAN TAKE AMAZING SKY PHOTOS AT NIGHT? THEN, IF I WERE YOU, I'D LEAVE THE CITY FOR A FEW DAYS TO PHOTOGRAPH SKIES FULL OF STARS, AND THEN I'D PRINT THOSE PHOTOGRAPHS AND START JOINING THOSE STARS WITH LINES, CREATING THINGS INSPIRED ON THOSE CELESTIAL BODIES. IF YOU CAN DO THAT, I BELIEVE THOSE ILLUSTRATIONS MIGHT END UP BECOMING A BOOK LIKE THIS ONE.

Shaping Clouds:
Process and Technique

Here is a description of the process and the techniques involved in the art of shaping clouds.

1 PHOTOGRAPH SOME CLOUDS.

I BELIEVE THAT THE FIRST THING THAT INSPIRED ME TO DO THIS WAS THE SHAPE OF THE CLOUDS THAT I SAW DURING MY HOLIDAYS IN MEXICO. IT ALL STARTED THERE. I DIDN'T GO TO MEXICO WITH THE IDEA OF TAKING PHOTOGRAPHS OF CLOUDS, BUT AS SOON AS I TOOK THE FIRST PICTURE OF A CLOUD, I COULDN'T STOP; EVERY TIME WE WERE ABOUT TO HIT THE ROAD, I HAD THE CAMERA READY, RIGHT NEXT TO ME, JUST IN CASE A CLOUD GAVE ME AN IDEA FOR AN ILLUSTRATION.

2️⃣ CHOOSE A CLOUD AND PRINT IT.

ONCE YOU'VE PHOTOGRAPHED A CLOUD THAT YOU LIKE, YOU HAVE TO *PRINT IT.* THE BIGGER YOU PRINT IT, THE EASIER IT WILL BE TO ADD SOME DETAILS THAT WILL HELP YOU GIVE THE ILLUSTRATION A PERSONALITY AND TELL A STORY. I'M SURE THAT SOME PEOPLE WOULD PREFER TO DO EVERYTHING DIGITALLY, BUT I'M THE KIND OF GUY WHO BELIEVES THAT NOTHING CAN BEAT A BLANK PAGE AND A PENCIL.

3️⃣ BEFORE DRAWING, LOOK FOR REFERENCES.

SOMETHING THAT'S VERY HELPFUL FOR ME IS TO *LOOK FOR REFERENCES* BEFORE I START DRAWING. IT DOESN'T MATTER IF WHAT YOU'RE PLANNING TO ILLUSTRATE IS A REAL, MYTHOLOGICAL, OR FANTASTICAL CREATURE; REFERENCES WILL GUIDE YOUR IMAGINATION AND YOUR HAND BECAUSE THINGS ARE EASY TO DRAW WHEN YOU CAN LOOK AT SOMETHING THAT IS SIMILAR. EVEN IF IS JUST AN EYE OR A FINGER, A REFERENCE CAN MAKE A DIFFERENCE BETWEEN JUST ONE MORE DRAWING AND AN EYE-CATCHING ILLUSTRATION THAT PEOPLE WON'T FORGET.

REMEMBER THAT THIS IS A GAME OF IMAGINATIVE FREEDOM. I STRONGLY ADVISE YOU TO DO THIS ONLY WHEN YOU HAVE THE TIME, BECAUSE THE MORE TIME YOU DEDICATE TO DETAILS, THE BETTER YOUR ILLUSTRATIONS.

"When the sky is totally covered by the dark clouds, be strong enough to see the bright stars beyond them."

4 TURN YOUR CLOUD INTO AN ILLUSTRATION.

WHEN YOU'VE CHOSEN A CLOUD, PRINTED IT, AND LOOKED FOR THE REFERENCES YOU NEED, THERE ARE TWO WAYS TO SHAPE YOUR CLOUD AND TURN IT INTO THE IDEA YOU HAVE IN MIND.

Using a light table

YOU'LL NEED A LIGHT TABLE AND SOME TRANSPARENT PAPER IF YOU'RE PLANNING TO USE THIS TECHNIQUE. ALL YOU HAVE TO DO IS TO TURN THE LIGHT TABLE ON, PLACE THE PRINTED PICTURE OF YOUR CLOUD THERE, AND COVER IT WITH TRANSPARENT PAPER. I RECOMMEND YOU USE SOME ADHESIVE TAPE TO KEEP BOTH PAPERS ALIGNED; IF ONE OF THE PAPERS MOVES AND YOU HAVEN'T REALIZED IT, YOU MIGHT END UP HAVING AN ILLUSTRATION THAT DOESN'T HAVE THE SAME SHAPE AS THE CLOUD YOU USED. ONCE EVERYTHING IS READY, USE THE CLOUD SHAPE AS AN INSPIRATION TO DRAW A REPRESENTATION OF WHAT YOU'VE IMAGINED ON THE TRANSPARENT PAPER.

DRAWING DIRECTLY OVER THE PRINTED CLOUDS

THIS TECHNIQUE MIGHT TAKE YOU MORE TIME, BUT IT'S A GOOD WAY TO ACHIEVE THE SAME RESULTS IF YOU DON'T HAVE A LIGHT TABLE OF YOUR OWN AND YOU CAN'T BORROW ONE. FIRST OF ALL, PRINT THE CLOUD YOU'RE PLANNING TO WORK WITH AND, USING A WELL-SHARPENED PEN, DRAW FREESTYLE OVER THE CLOUD; YOU CAN DRAW OVER IT AS MANY TIMES AS YOU WANT TO, UNTIL YOU HAVE AN ILLUSTRATION THAT YOU'RE HAPPY WITH. ONCE YOU GET IT, USE A PEN TO MARK THE LINES THAT YOU'RE FINALLY GOING TO USE AS THE BASE FOR YOUR ILLUSTRATION. NOW THAT YOU HAVE YOUR CREATION READY TO BE ILLUSTRATED, PLACE A TRANSPARENT PAPER OVER THE PRINTED CLOUD AND USE THE PEN STROKES YOU'VE JUST MADE AS A GUIDE. YOU'LL CREATE THE ILLUSTRATION FASTER BECAUSE YOU'VE EXPERIMENTED WITH THE CLOUD SHAPES BEFORE, AND NOW YOU'LL JUST MAKE A FINAL COPY OF YOUR CLOUD SKETCH.

I'VE USED BOTH TECHNIQUES AND, NOWADAYS, I FEEL MORE COMFORTABLE WITH THE SECOND TECHNIQUE. ONE THING THAT I HAVEN'T CHANGED IS THAT I ALWAYS USE A BLACK PEN BECAUSE I'M A HUGE FAN OF BLACK-AND-WHITE ILLUSTRATIONS BUT YOU CAN USE WHATEVER YOU WANT—YOU CAN EVEN PAINT YOUR CREATIONS WITH DIFFERENT COLORS!

5

DIGITIZE YOUR SKETCH AND COMBINE IT WITH THE PHOTOGRAPH OF YOUR CLOUD.

I DON'T SCAN EVERY CLOUD SKETCH AS SOON AS I FINISH IT; I PREFER TO MAKE AS MANY ILLUSTRATIONS AS I FEEL LIKE DOING (THERE HAVE BEEN DAYS I'VE MADE FOUR OF THEM IN JUST A FEW HOURS) AND THEN I STOP DRAWING AND GO DO SOMETHING ELSE. BY DOING THAT, I NEVER REACH THE POINT THAT I GET TIRED OF DOING CLOUD SKETCHES, AND, AT THE SAME TIME, I KEEP MY MIND THINKING OF THE CLOUDS' SHAPES, WHICH HELPS ME COME UP WITH NEW IDEAS THAT I'LL USE THE NEXT TIME I'LL SIT DOWN AND START DRAWING.

ONCE I HAVE ENOUGH ILLUSTRATIONS, I SCAN THEM ALL TOGETHER IN HIGH RESOLUTION AND THEN COMBINE THEM WITH THE ORIGINAL CLOUDS USING PHOTOSHOP. I DON'T DIGITALLY CHANGE THE ORIGINAL ILLUSTRATIONS OR THE SHAPE OF CLOUDS TO MAKE THEM FIT; IF I SEE THAT THE COMBINATION OF BOTH CLOUD AND ILLUSTRATION DOESN'T WORK, I'LL DO THE NECESSARY CORRECTIONS ON THE ORIGINAL SKETCH AND SCAN IT AGAIN. IF IT STILL DOESN'T WORK, I'LL START FROM SCRATCH.

THE RESULT HAS TO BE A NEW IMAGE WHERE ANYONE IS ABLE TO SEE THE CLOUD AND THE ILLUSTRATION AS A SINGLE THING.

Complete Sketches

My best illustrations inspired by clouds

WHEN I FIRST THOUGHT ABOUT TURNING MY
CLOUD SKETCHES INTO THE CLOUD SKETCHING PROJECT,
I DECIDED TO CHOOSE TEN CLOUDS AND RECALL THE FIRST
THING THAT CAME INTO MY MIND WHEN I PHOTOGRAPHED
THEM BACK IN MEXICO. WHEN I LOOKED BACK AT THOSE
CLOUDS AGAIN, I HAD NEW THOUGHTS AND IDEAS, MAKING
THOSE CLOUDS SKETCHES FUNNIER AND MORE EYE—CATCHING.
RIGHT AFTER I SHARED MY FIRST TEN CLOUDS, I LOOKED
FOR PEOPLE'S REACTION TO MY PROJECT, AND
THE FEEDBACK WAS AWESOME!

SINCE THEN, I'VE BEEN TURNING LOTS OF CLOUDS
INTO ILLUSTRATIONS, AND NOW, THE MORE I DO IT,
THE MORE FUN I HAVE!

T. REX CLOUD

I STILL CAN REMEMBER THE MOMENT I TOOK THIS PHOTOGRAPH. WE WERE AT A REST AREA, STANDING NEXT TO OUR FRIEND'S CAR, WHEN I LOOKED AHEAD AND SAW THIS BEAUTIFUL CLOUD COMING OUT FROM BEHIND A MOUNTAIN: A BEAUTIFUL T. REX LOOKING AT US. THANK GOD BY THAT TIME OF THE JOURNEY, I WAS TAKING THE CAMERA WITH ME EVERYWHERE. WHEN I STARTED DRAWING IT, I DECIDED TO LOOK FOR REFERENCES BECAUSE THIS CLOUD WAS SO PERFECT TO ME THAT I WANTED TO MAKE IT LOOK AS REAL AS POSSIBLE.

OUT OF THE BLUE

ORDINARY THUNDERSTORM CLOUDS CAN BE SEVERAL MILES WIDE AT THE BASE AND EXTEND MORE THAN 7 MILES (12 KM) INTO THE SKY. SUPERCELL THUNDER-STORMS CAN RISE 11 MILES (18 KM) INTO THE ATMOSPHERE.

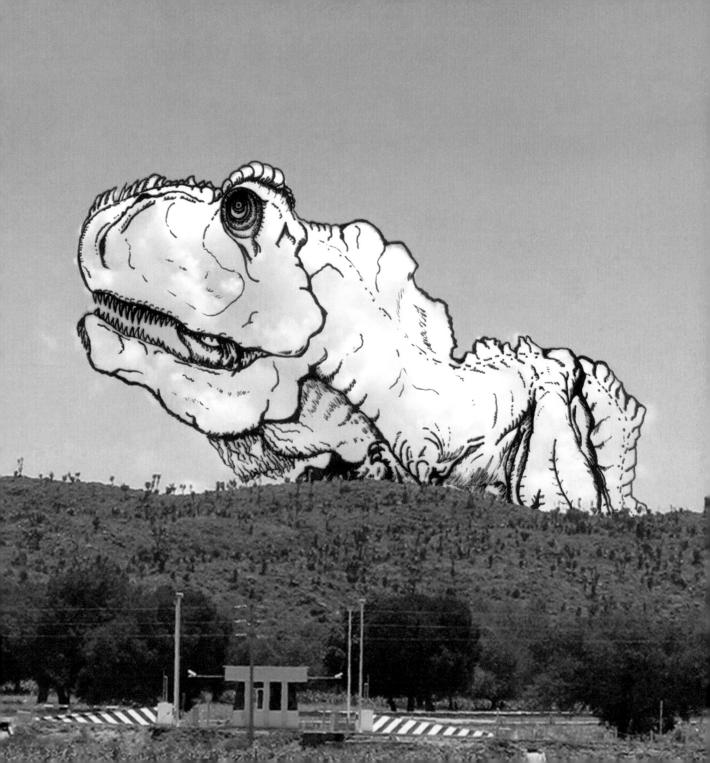

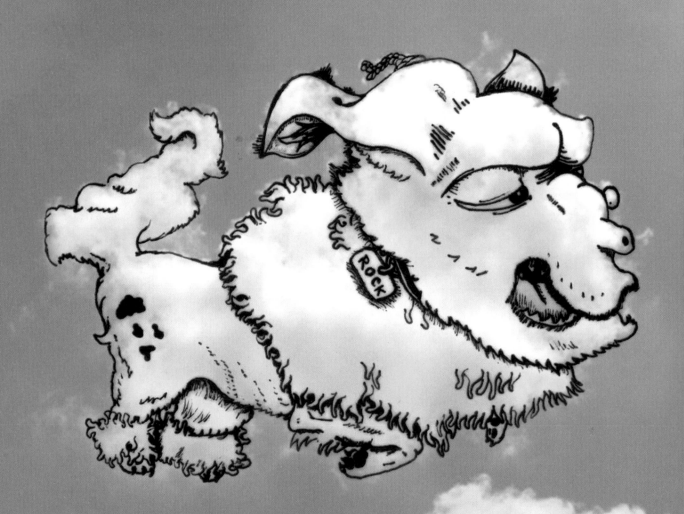

ROCK THE WEIRD DOG CLOUD

LET ME TELL YOU A LITTLE SECRET: THIS WAS THE FIRST CLOUD I ILLUSTRATED WHEN I STARTED WITH THIS PROJECT, AND, EVEN THOUGH IS NOT MY BEST CLOUD SKETCH, I'M VERY PROUD OF IT BECAUSE IT'S THE RESULT OF ALL THE EXCITEMENT I HAD WHEN I FINALLY DECIDED IT WAS TIME TO SHAPE CLOUDS.

ITS COLLAR, THE AWFUL HAIRCUT WITH THE LITTLE TAIL ON ITS HEAD, AND EVEN THAT HUGE WART ON ITS NOSE WERE ACCESSORIES THAT HELPED ME SHAPE THIS CREATURE. AS I KEPT DRAWING CLOUDS, I IMPROVED MY STYLE AND LOOKED AT EACH CLOUD TWICE BEFORE I STARTED DRAWING IN ORDER TO MAKE THE MOST OF IT AND TO END UP WITH A MORE INTERESTING CREATURE. BUT THIS LITTLE DOG WILL ALWAYS HAVE A PLACE IN MY HEART BECAUSE HE IS THE FIRST ONE.

PARROT FISH CLOUD

I DON'T KNOW IF IT'S BECAUSE THE SKY IS SO BLUE THAT IT LOOKS TO ME LIKE A VAST OCEAN, BUT, MOST OF THE TIME, I CAN'T HELP BUT SEE BIRDS OR SEA CREATURES. IN THIS CASE, MY MIND CREATED A COMBINATION OF A PARROT AND A FISH. THIS FANTASTIC CREATURE'S FEATHERS AND SCALES WERE VERY USEFUL IN TURNING CLOUDS' IMPERFECTIONS INTO SOMETHING SUITABLE. AFTER I CREATED THIS IMAGINARY ANIMAL, I DISCOVERED THAT THERE'S A FISH WITH THIS SAME NAME. BUT, DON'T WORRY, I DID A LITTLE RESEARCH, AND I CAN ASSURE YOU THAT IT HAS NO RESEMBLANCE TO MINE, SO THERE'S NOTHING TO WORRY ABOUT.

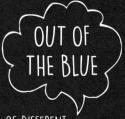

OUT OF THE BLUE

THERE ARE A RANGE OF DIFFERENT TYPES OF CLOUDS; THE MAIN ONES ARE STRATUS, CUMULUS, NIMBUS, AND CIRRUS.

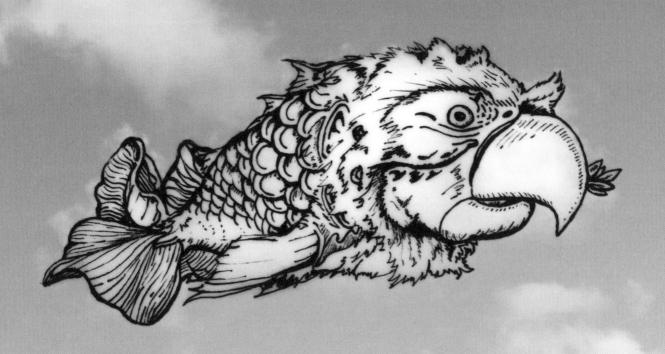

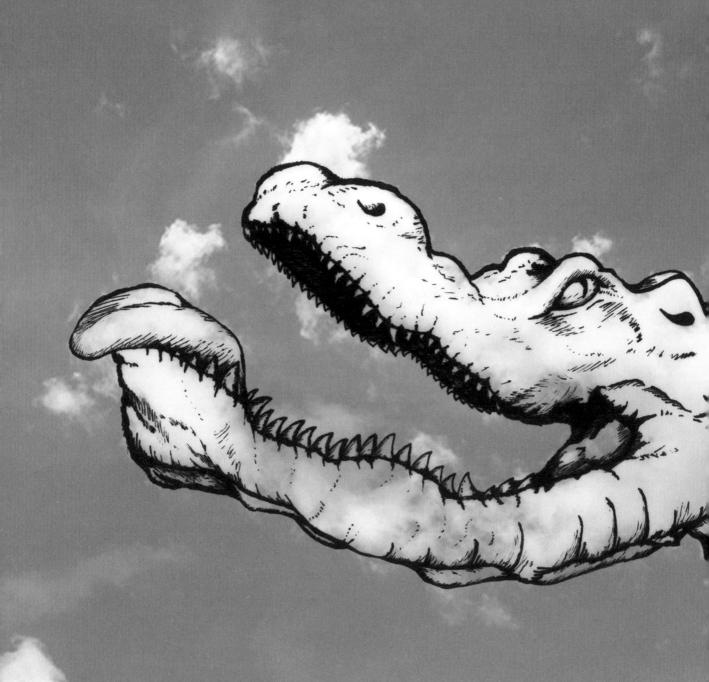

CROCODILE CLOUD

THIS CLOUD IS PART OF A BIGGER PHOTOGRAPH I USED MORE THAN ONCE ON THIS PROJECT. WHEN I FIRST TOOK IT, I BELIEVED THAT THIS CLOUD WOULD BE A FUNNY BARKING DOG, BUT THEN I REALIZED THAT ITS JAW WAS TOO LONG, AND THAT WOULD'VE MADE IT LOOK LIKE A CARTOON DOG, AND BY THAT TIME, I'D ALREADY DRAWN MY ROCK THE WEIRD DOG CLOUD (SEE PAGE 26). I THOUGHT THAT TWO DOGS WERE TOO MANY, SO I THOUGHT ABOUT IT FOR A FEW DAYS UNTIL I SAW THAT THIS CLOUD COULD BE A GREAT CROCODILE. I ADMIT THAT THIS ILLUSTRATION WASN'T EASY, BECAUSE I WANTED TO MAKE IT AS REAL AS POSSIBLE USING THE CLOUDS' SHADES.

WHILE I WAS DRAWING THIS CROCODILE, I STARTED USING JUST A PART OF THE CLOUD, NOT THE WHOLE THING, FOR THE FIRST TIME; SOMETIMES IT IS BETTER TO LEAVE THE COMPLICATED PARTS OF THE CLOUD OUT OF THE ILLUSTRATION. I HAD TO MAKE THIS CROCODILE IN TWO SESSIONS: I ADDED THE REST OF ITS TONGUE (AT FIRST, IT ONLY HAD THE TIP), THE INSIDE OF ITS MOUTH, AND SOME DETAILS BELOW ITS JAW THE SECOND TIME, WHICH IMPROVED IT AND MADE ME FEEL MORE COMFORTABLE WITH THE FINAL RESULT.

LONG-NECK PLATYPUS CLOUD

WHEN I PHOTOGRAPHED THIS CLOUD, I WAS THINKING ABOUT MAYBE TURNING IT INTO A PEACOCK; THE PLATYPUS'S HEAD WAS GOING TO BE PEACOCK'S CLOSED TAIL, AND WHAT YOU NOW SEE AS ITS TAIL WOULD HAVE BEEN THE HEAD, ALSO USING THE SMALL CLOUDS YOU CAN SEE FLYING AROUND ITS TAIL. WHEN I FINALLY STARTED TO DRAW THIS CLOUD, I REALIZED THAT A PLATYPUS WOULD LOOK MUCH BETTER. BUT I HAD A PROBLEM: PLATYPUSES ARE SHORT—NECKED, FAT ANIMALS, SO I DECIDED TO CREATE MY OWN VERSION OF A PLATYPUS WITH A LONG NECK AND A THINNER BODY. THE GOOD THING ABOUT IMAGINING THINGS IS THAT YOU'RE FREE TO DO IT THE WAY YOU WANT, AND IT'S ALWAYS GOING TO BE PERFECT.

"Brushing the clouds away from my eyes, I see clarity in the raindrop and beauty in the first ray of morning sun. . . . life is strange and wondrous."

VIRGINIA ALISON

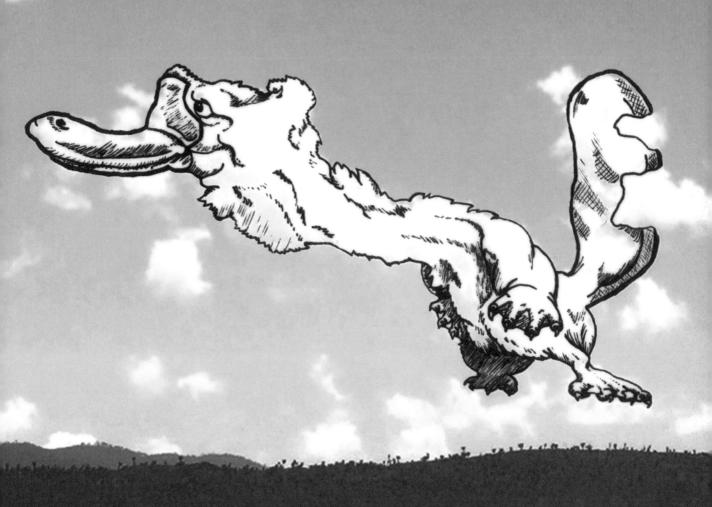

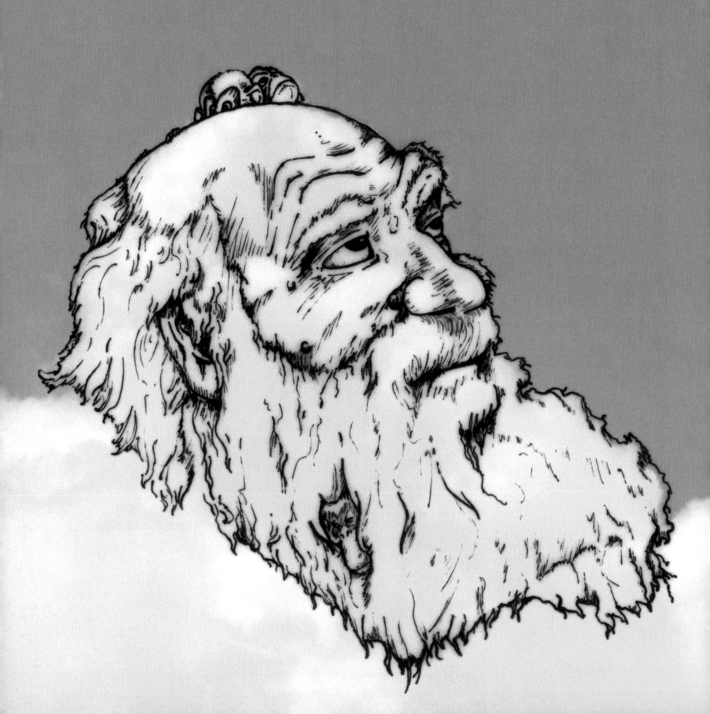

DARWIN CLOUD

THIS IS ANOTHER EXAMPLE THAT THERE'S NO NEED TO USE THE WHOLE CLOUD; SOMETIMES, A SMALL PART OF IT IS ALL YOU NEED TO COME UP WITH SOMETHING CREATIVE. AT FIRST THIS WAS GOING TO BE A BOLD MAN WITH A LONG BEARD; THE NEXT DAY, IT WAS GOING TO BE ONE OF THE EXPERT BALLOON—TWISTING CLOWNS, BUT BY THE TIME I STARTED SKETCHING THIS CLOUD, I REALIZED THAT I STILL NEEDED TO THINK OF A WAY TO USE THAT LITTLE PART OF THE CLOUD THAT WAS OVER WHAT WAS GOING TO BE HIS HEAD. AND THEN I SAW THE MONKEYS.

I STARTED LOOKING FOR SOME PHOTOGRAPHS AND DRAWINGS OF DARWIN TO GET SOME DETAILS OF HIS HEAD THAT I COULD USE; I ALSO SEARCHED FOR SOME MONKEY ILLUSTRATIONS. ONCE I STARTED DRAWING DARWIN, I REALIZED THAT THE LOOK ON HIS FACE, AND THE MONKEYS I HID OVER HIS HEAD AND UNDERNEATH HIS BEARD HELPED ME REPRESENT THE MOMENT DARWIN FIRST THOUGHT ABOUT HIS THEORY OF EVOLUTION.

BIG-HEADED DUCK CLOUD

I LOVE THIS ONE. WHEN I SAW THIS CLOUD, I IMMEDIATELY KNEW THAT IS WAS GOING TO BE A BIG-HEADED DUCK. IF YOU LOOK AT THE PICTURE AGAIN, PAY ATTENTION TO THE LITTLE CLOUD THAT IS ABOVE THE CLOUD I USED, AND MAYBE YOU'LL SEE THAT IT LOOKS LIKE A BABY PTERODACTYL LEARNING TO FLY.

THIS IS SOMETHING THAT HAPPENS TO ME A LOT: EVERY TIME I LOOK AT THE PHOTOGRAPHS OF CLOUDS I TOOK IN MEXICO, I FIND NEW SHAPES AND DIFFERENT CREATURES TO DRAW. I BELIEVE THIS IS BECAUSE THERE ARE NO RIGHT OR WRONG IDEAS WHEN YOU'RE LOOKING FOR SHAPES IN CLOUDS.

OUT OF THE BLUE

FOG IS A STRATUS CLOUD THAT APPEARS VERY CLOSE TO THE GROUND.

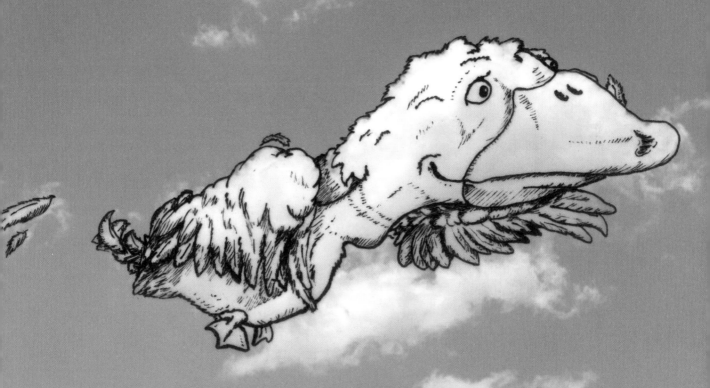

"The clouds—the only birds that never sleep."

VICTOR HUGO

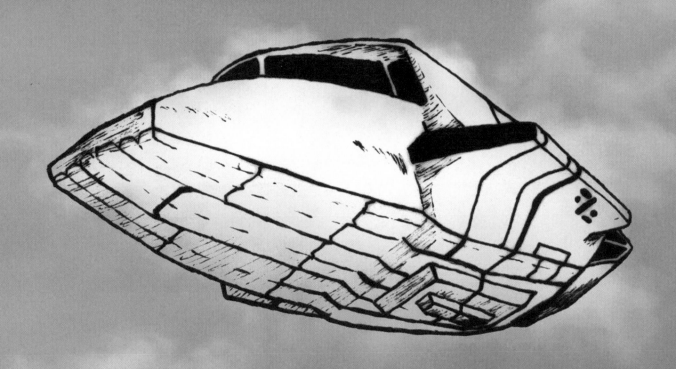

"The sun always shines above the clouds."

PAUL F. DAVIS

V SKY FIGHTER CLOUD

WHEN I WAS A LITTLE KID, I USED TO WATCH THE TV SERIES *V*, AND LET ME TELL YOU
THAT THAT STORY ABOUT ALIENS DISGUISED AS HUMANS BLEW MY MIND. I STILL REMEMBER
BEING AT MY HOUSE IN ARGENTINA, TRYING TO BUILD A REPLICA OF THE WEAPONS THEY HAD
USING JUST LEGO BRICKS. I BELIEVE THAT'S WHY, WHEN I FIRST LOOKED AT THIS CLOUD, I THOUGHT
THAT IT WOULD BE A GREAT SPACESHIP, BECAUSE IT HAD THE SAME SHAPE AS THE *V* SKY FIGHTER.
I HAD TO LOOK FOR SOME IMAGES ONLINE BECAUSE, EVEN THOUGH I REMEMBERED IT AS A
VERY SIMPLE SHIP, AFTER I STARTED DRAWING IT I REALIZED THAT THE IMAGE I HAD IN MY MIND
WAS NOT CLEAR ENOUGH TO BE MY ONLY REFERENCE.

OUT OF
THE BLUE

OTHER PLANETS IN OUR SOLAR
SYSTEM HAVE CLOUDS. VENUS HAS
THICK CLOUDS OF SULFUR DIOXIDE,
WHILE JUPITER AND SATURN HAVE
CLOUDS OF AMMONIA.

RUSSIAN CHICKEN CLOUD

OH, MY LOVELY RUSSIAN CHICKEN! BY THE TIME THIS PHOTOGRAPH WAS TAKEN, I HAD SHARED MY *CLOUD SKETCHING* IDEA WITH MY GOOD FRIENDS LETICIA, VERONICA, AND JUAN, SO I WAS NO LONGER THE ONLY ONE LOOKING FOR SHAPES IN CLOUDS. LETICIA WAS THE ONE WHO SAW THIS CLOUD AHEAD, SO SHE TOOK THE CAMERA AND PHOTOGRAPHED IT BEFORE WE MISSED IT. WHEN SHE POINTED IT OUT TO ME, WE BOTH SAW A HUGE CHICKEN OVER A CLOUD THAT, IN THE BEGINNING, WAS A DIVA CHICKEN (THAT'S WHY IT HAS A HUGE NECKLACE MATCHING ITS EARRINGS). BUT THEN, WHILE I WAS DRAWING IT, I REALIZED THAT THE CURLY HAIR WOULDN'T WORK, SO I DECIDED TO MAKE IT LOOK LIKE A FUR HAT, WHICH ALSO GAVE ME THE IDEA TO MAKE IT WEAR A SMALL FUR COAT; WITHOUT THAT, IT WOULD LOOK LIKE THAT CHICKEN HAD A HUGE HUMP. INSTEAD, SHE BECAME A BEAUTIFUL AND SOPHISTICATED RUSSIAN CHICKEN!

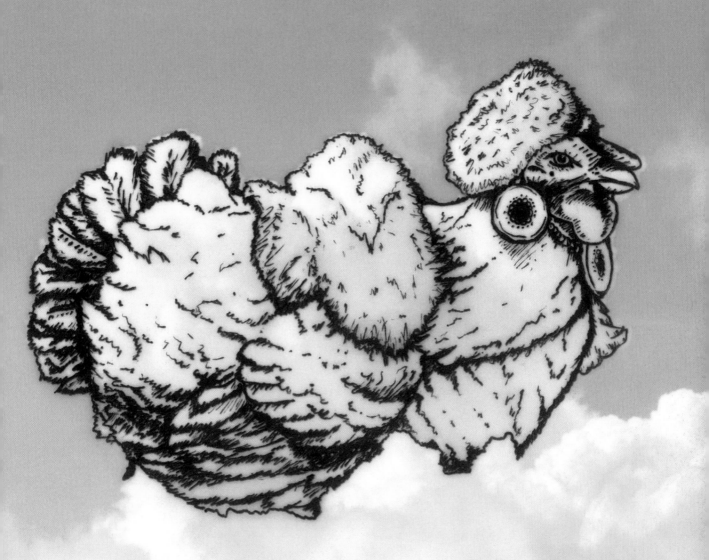

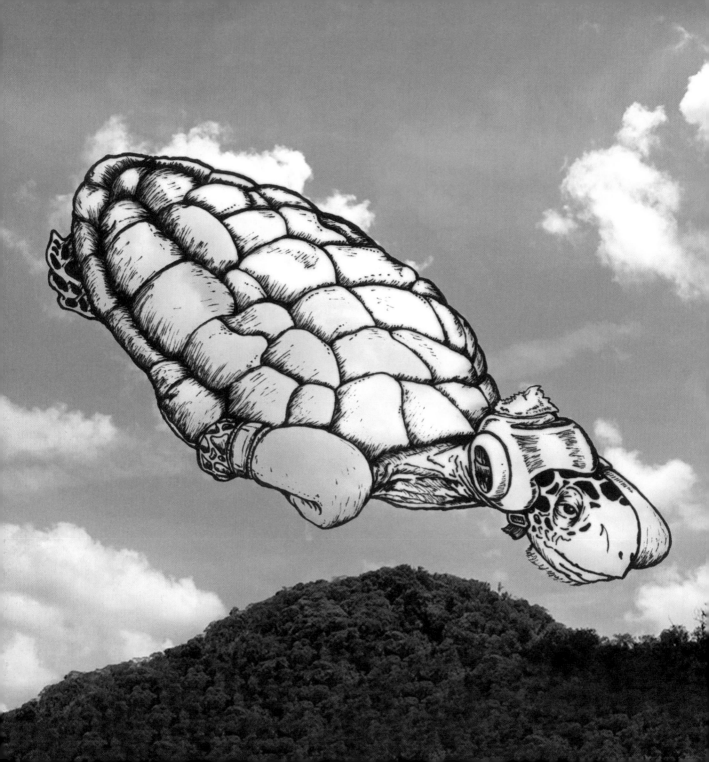

BOXING TURTLE CLOUD

IF YOU PAY ATTENTION TO THE PHOTOGRAPH, YOU'LL SEE THAT, AT THE BOTTOM LEFT OF THE IMAGE, THERE'S THE JAW OF THE CROCODILE CLOUD (PAGE 30). BOTH CLOUDS WERE ADJACENT WHEN I TOOK THE PHOTOGRAPH.

AT FIRST, THIS CLOUD WAS GOING TO BE JUST A REGULAR TURTLE FALLING IN THE SKY. BUT THEN, I TURNED THE EXTRA CLOUDS RIGHT NEXT TO ITS HEAD INTO A BOXING GLOVE, WHICH GAVE ME THE IDEA TO MAKE THE TURTLE WEAR BOXING HEADGEAR. FROM THAT MOMENT ON, I STARTED ADDING DETAILS UNTIL I TURNED IT INTO THE MOST DANGEROUS BOXING TURTLE THAT THE WORLD WILL EVER KNOW!

OUT OF THE BLUE

A CLOUD IS A LARGE GROUP OF TINY WATER DROPLETS THAT IS VISIBLE IN THE AIR.

MONSTER HEAD CLOUD

I WANTED TO PROVE THAT MORE THAN ONE CREATURE CAN BE INSPIRED BY THE SAME CLOUD. IT HAS HAPPENED TO ALL OF US: WHEN WE ARE LOOKING AT THE SAME CLOUD WITH OTHER PEOPLE, SOMETIMES WE DO NOT SEE THE SAME THINGS. THAT'S THE REASON I TOOK THE CLOUD THAT ORIGINALLY INSPIRED MY BOXING TURTLE CLOUD (PAGE 42) AND USED IT AS THE STARTING POINT FOR THIS BIZARRE HEAD WITHOUT A BODY. AT THE BEGINNING, I THOUGHT IT COULD BE SOME KIND OF "CLOUD EATER", BUT THEN I DECIDED TO TURN THE REST OF THE CLOUD INTO A FIREBALL. I'M VERY HAPPY WITH THE FINAL RESULT.

"I can be jubilant one moment and pensive the next. And a cloud could go by and make that happen."

BOB DYLAN

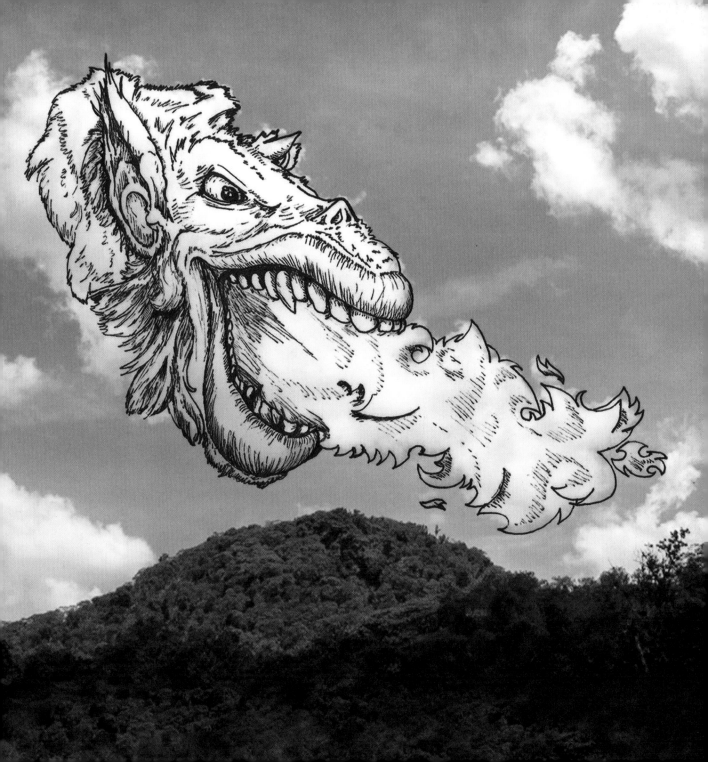

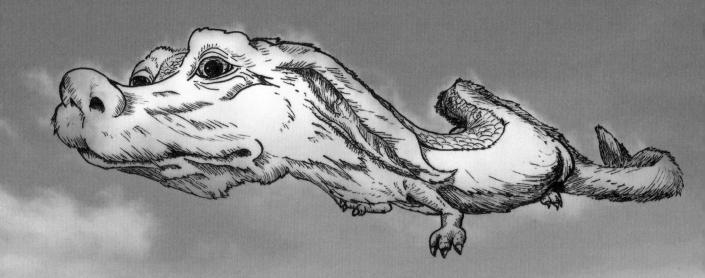

"Often I have found myself gazing up at clouds— yesterday's seas and tomorrow's streams—to think of them as floating on an ultraviolet sea, beyond which is the infinity of space that presents so much wonder and so many questions."

FENNEL HUDSON

FALKOR CLOUD

THERE WAS A TIME IN MY LIFE WHEN I'D SEEN THE MOVIE
THE NEVERENDING STORY SO MANY TIMES THAT I'D MEMORIZED
THE DIALOGUE OF ALL CHARACTERS. THIS HALF—DOG,
HALF—DRAGON CREATURE HAS BEEN PART OF MY CHILDHOOD
MEMORIES EVER SINCE. WHEN I LOOKED AT THIS CLOUD,
IT BROUGHT THOSE MEMORIES BACK, AND I WANTED TO
TURN THE CLOUD INTO A TRIBUTE TO THE FLYING CREATURE
THAT WAS AN ICON DURING MY EARLY YEARS—FALKOR.
SOME OF MY FRIENDS SAID THAT THIS CLOUD ALSO COULD
HAVE BEEN A SNAKE WITH A HUGE HEAD, AND THEY'RE RIGHT,
BUT I PREFERRED TO TURN IT INTO THIS MAGICAL CREATURE.

OUT OF
THE BLUE

THIN AND WISPY CIRRUS CLOUDS
APPEAR HIGH IN THE SKY.

FREEZING WORM CLOUD

WHEN I WAS A CHILD, I LOVED CARTOONS OF ALL KINDS. SOMETIMES, THE KIND OF ILLUSTRATION YOU USE CAN HELP YOU TELL A DIFFERENT STORY. FOR EXAMPLE, IF THIS FREEZING WORM LOOKED MUCH MORE REAL, IT WOULD TELL YOU A DIFFERENT STORY. THE SCARF AND THE SMALL ICICLES ON ITS NOSE AND EARS ARE ACCESSORIES I USED TO HELP ME VISUALIZE THE COLD. WITH THIS SIMPLE, YET FUNNY, ILLUSTRATION I WANTED TO MAKE PEOPLE FEEL THAT THEY COULD ADOPT THAT FREEZING WORM AS THEIR PET.

OUT OF THE BLUE

HIGH—LEVEL CIRRUS CLOUDS CAN TRAVEL UP TO 100 MILES (161 KM) PER HOUR, THANKS TO THE JET STREAM. CLOUDS THAT ARE PART OF A THUNDERSTORM USUALLY TRAVEL AT 30 TO 40 MILES (48 TO 64 KM) PER HOUR.

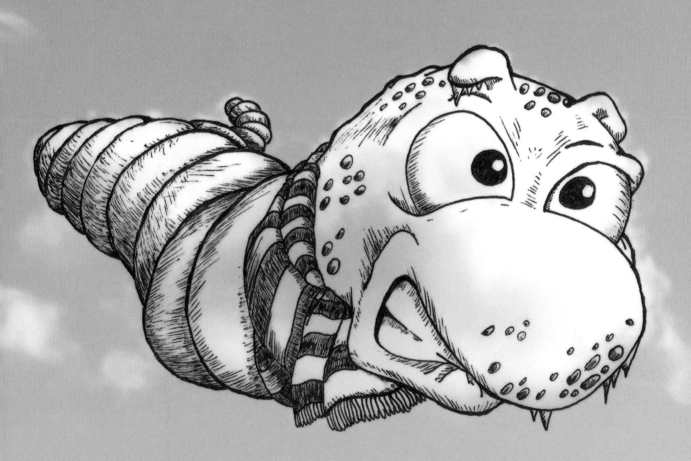

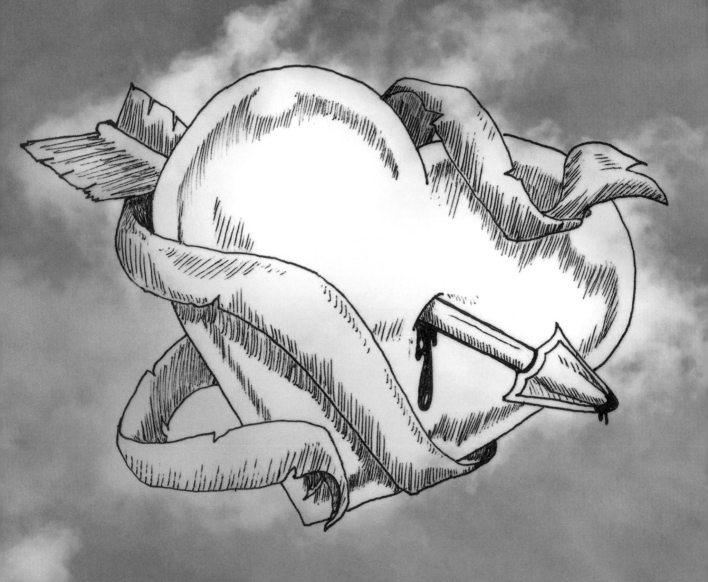

HURT HEART CLOUD

WHO HASN'T SEEN A CLOUD THAT LOOKED LIKE A HEART?
I HAVE. I BELIEVE THAT ALL THOSE YEARS READING AND
TAKING IDEAS FROM GRAFFITI AND TATTOO MAGAZINES
INSPIRED THIS ILLUSTRATION. THE THING IS, FROM MY
EXPERIENCE, EVERY TIME PEOPLE SEE AN ARROW PIERCING
A HEART, THEY AUTOMATICALLY THINK ABOUT LOVE. I WANTED
TO CHANGE THAT PERCEPTION, WHICH IS WHY I ADDED THE
BLOOD AND DIDN'T WRITE A NAME IN THE RIBBON AROUND
THE HEART. I BELIEVE THAT BOTH PAIN AND LOVE CAN FEEL
LIKE AN ARROW GOING THROUGH YOUR HEART.

"Clouds come floating into my life, no longer to carry rain or usher storm, but to add color to my sunset sky."

RABINDRANATH TAGORE

GENIE CLOUD

BELIEVE IT OR NOT, THIS CLOUD STARTED AS SOME KIND OF HALF—ELEPHANT, HALF—FISH CREATURE, BUT, AFTER TRYING IT A FEW TIMES, I REALIZED I HAD TO THINK ABOUT SOMETHING ELSE. ONE DAY, I WAS LOOKING AT THAT PICTURE WHEN THE DARKER PART OF THE CLOUD REMINDED ME OF A RAY COMING OUT OF A HAND, AND THE SHAPE OF THE CLOUD THEN LOOKED, TO ME, LIKE A GENIE COMING OUT OF A MAGIC LAMP. I SEARCHED FOR SOME REFERENCES, BECAUSE THE ONLY GENIE I COULD THINK OF WAS ALADDIN'S BLUE GENIE (FROM THE 1992 DISNEY MOVIE), AND I WAS SURE THAT REFERENCE WOULD NEVER WORK. AFTER LOOKING TO A FEW GENIES, I FINALLY DECIDED TO CREATE MY OWN, SOME KIND OF ITALIAN GENIE THAT'S SHOWING HIS POWER AT THE SAME TIME HE WANTS TO SHOW YOU HIS BICEPS.

"Nature is a mutable cloud which is always and never the same."

RALPH WALDO EMERSON

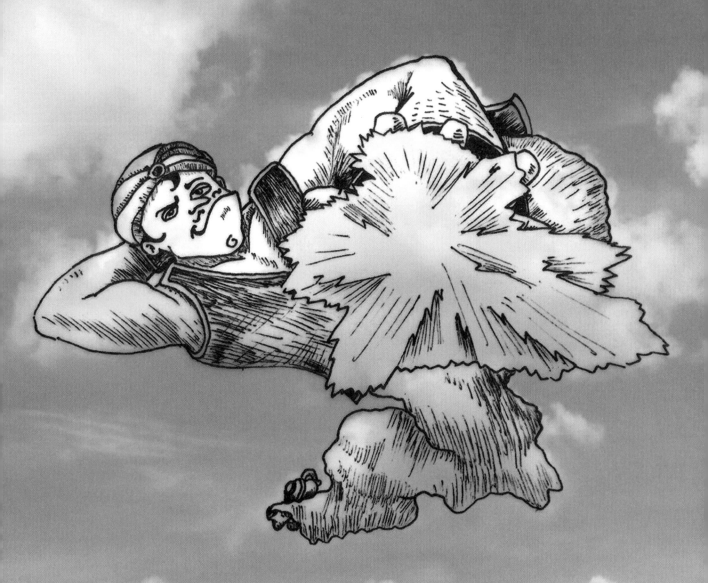

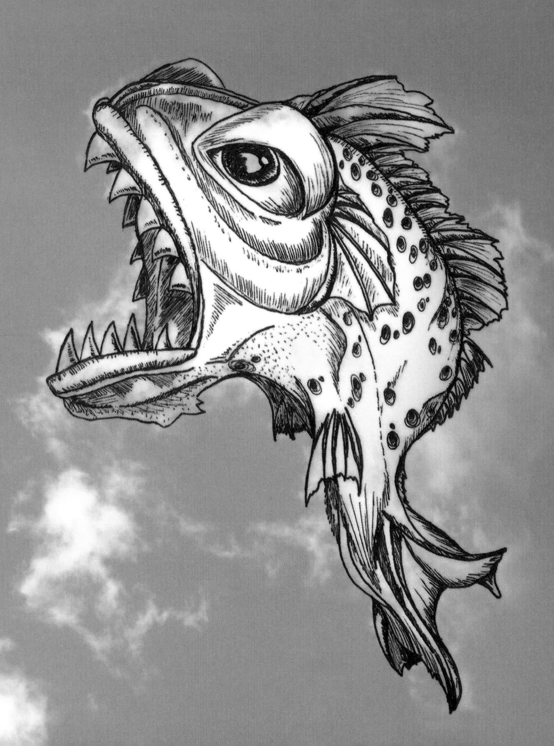

PIRANHA CLOUD

AS SOON AS I ENVISIONED THE MOUTH WITH ITS TEETH, I PHOTOGRAPHED THIS CLOUD BECAUSE I KNEW IT WAS GOING TO BE A PIRANHA. MAYBE IT'S NOT AS ROUNDED AS THE FISH YOU ALL KNOW, BUT FOR ME, IT'S ONE OF THE MOST BEAUTIFUL PIRANHAS I'VE EVER SEEN. I WANTED TO MAKE IT LOOK LIKE A DANGEROUS ANIMAL, AND, BY THE LOOK IN ITS EYES, EVERYONE CAN SEE THAT IT'S ABOUT TO BITE SOMEONE OR SOMETHING.

OUT OF THE BLUE

CLOUDS "FLOAT" BECAUSE WATER VAPOR IS LESS DENSE THAN THE SURROUNDING DRY AIR, AND THE WATER DROPLETS IN CLOUDS ARE SO MINISCULE THAT THEY CAN STAY SUSPENDED IN THE SURROUNDING AIR CURRENTS.

TOUCAN CLOUD

THE FIRST THING I SAW WAS THE LITTLE BRANCH, WHICH SEEMED TO BE PART OF A TREE THAT WAS LEFT BEHIND A LONG TIME AGO. THE TOUCAN CAME RIGHT AFTER I LOOKED AT THE CLOUD WITH MY CAMERA AND PHOTOGRAPHED IT. I WANTED MY TOUCAN TO BE AS REAL AS POSSIBLE, SO, IN THE PROCESS, I LOOKED FOR SOME IMAGES UNTIL I GOT THE RIGHT TOUCAN; I LEARNED THAT THERE ARE MANY KINDS OF TOUCANS. I FOUND ENOUGH IMAGES TO BE ABLE TO "SEE" IT FROM MANY ANGLES, WHICH HELPED ME TO GET ALL THE DETAILS I NEEDED IN ORDER TO MAKE IT LOOK LIKE A REALISTIC ILLUSTRATION.

OUT OF THE BLUE

WATER THAT FALLS TO THE GROUND FROM THE CLOUDS— RAIN, SNOW, SLEET, AND HAIL —IS CALLED PRECIPITATION.

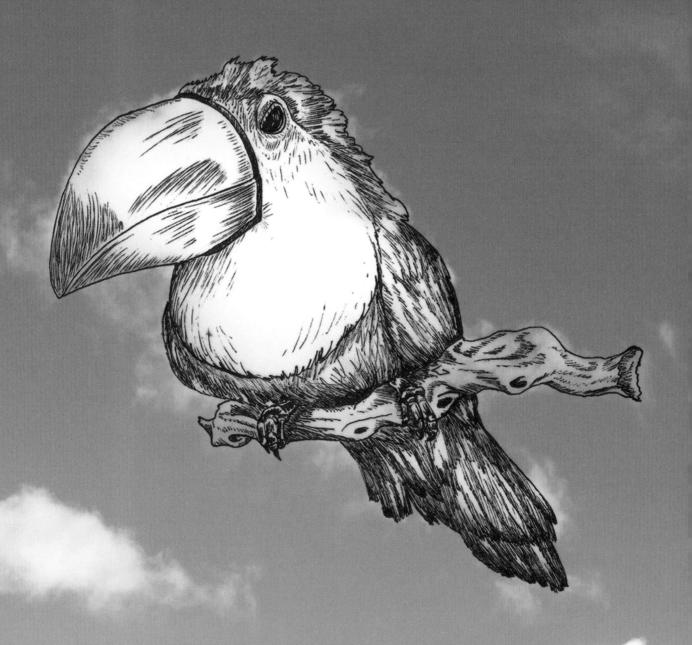

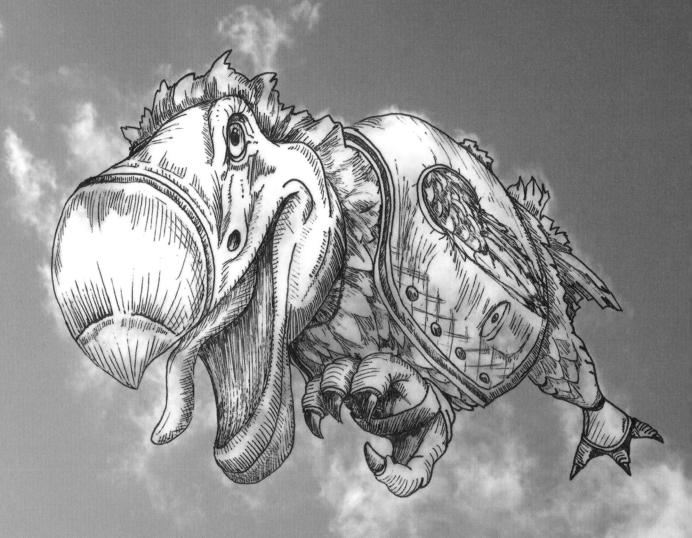

ROYAL DODO CLOUD

I HAVE TO ADMIT THAT I LOVE DRAWING EXTINCT CREATURES. IT ALLOWS ME TO GIVE THEM A WHOLE NEW PERSONALITY, BECAUSE MOST OF THE TIME, PEOPLE HAVE TO LOOK ONLINE IN ORDER TO SEE WHAT THE REAL CREATURE SUPPOSEDLY LOOKED LIKE.

I WANTED TO TURN THIS CLOUD INTO A "ROYAL DODO," WHICH WAS A MEMBER OF SOME KIND OF SECRET BROTHERHOOD WHERE THE LAST—AND MORE SOPHISTICATED—LIVING DODOS PROTECTED THEMSELVES. I ADDED THE FRATERNITY VEST AND THE CLASSIC SPATS TO MY DODO BECAUSE I THOUGHT THAT THOSE WERE THE KIND OF ACCESSORIES ALL "ROYAL DODOS" SHOULD BE WEARING IN A BROTHERHOOD LIKE THEIRS.

"The humble cumulus humilis— never hurt a soul."

GAVIN PRETOR-PINNEY

SLEEPING KOALA CLOUD

THIS IS ANOTHER EXAMPLE OF HOW A CLOUD CAN PROVIDE MORE THAN ONE IDEA FOR AN ILLUSTRATION. IF I'D USED THE WHOLE CLOUD, I PROBABLY WOULD HAVE TURNED IT INTO A RHINO HEAD WITH ITS HORN AND EVERYTHING, BUT I PREFERRED TO USE JUST A PART OF IT AND DRAW A SWEET KOALA TAKING A NAP OVER THE REST OF THE CLOUD. I COULD'VE DRAWN IT PRAYING, LAUGHING, OR JUST LOOKING AT THE SKY, BUT EVERYBODY KNOWS THAT THEY LOVE TO SPEND THE WHOLE DAY SLEEPING.

OUT OF THE BLUE

CLOUDS CAN CONTAIN
MILLIONS OF TONS OF WATER.

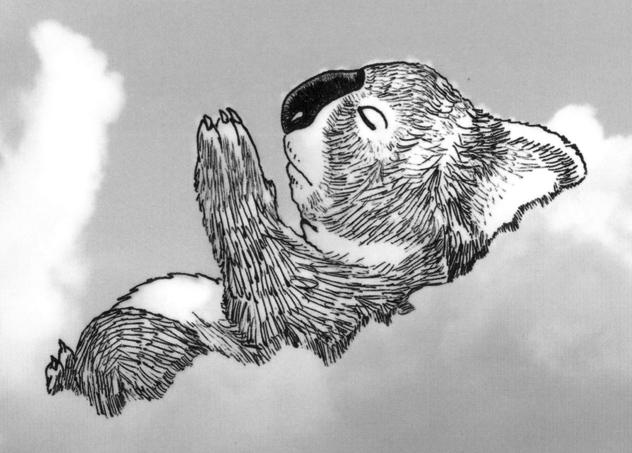

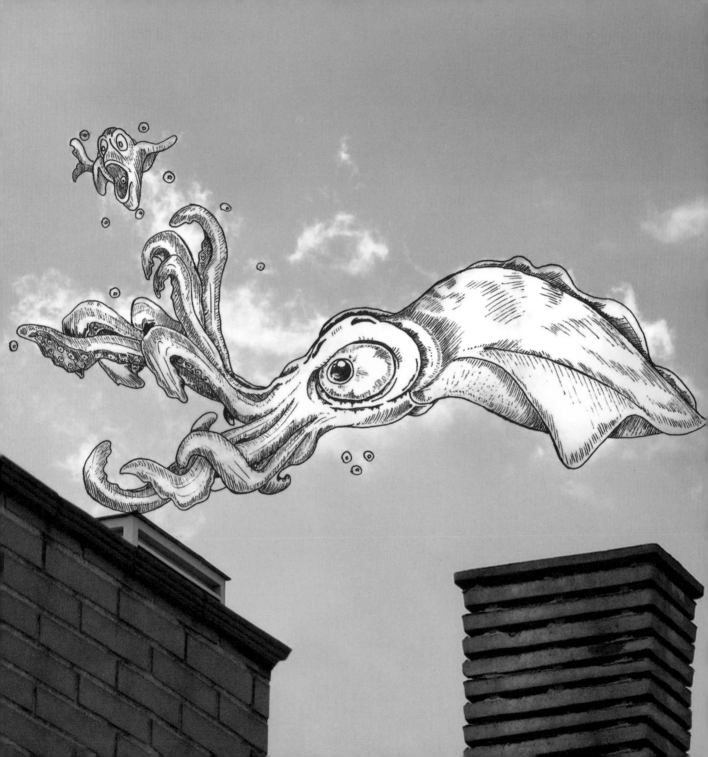

LITTLE FISH VERSUS GIANT SQUID CLOUD

I GOT THE IDEA OF A BIG SQUID FROM THE GIANT CREATURE THAT APPEARED IN THE WELL-KNOWN JULES VERNE BOOK *TWENTY THOUSAND LEAGUES UNDER THE SEA*. THE SHAPE OF THE CLOUD WAS PERFECT FOR RE-CREATING THIS CREATURE, AND WHILE I WAS DRAWING ITS TENTACLES AND ARMS, I REALIZED THAT THERE WAS A SMALL PART OF THE CLOUD ABOVE MY GIANT SQUID THAT LOOKED LIKE A SMALL FISH SCARED TO DEATH, WHICH WAS PERFECT! THE COMBINATION OF ALL THAT LOOKED LIKE "DAVID AND GOLIATH OF THE SEA" (WITH SOME BUBBLES AROUND THEM), AND IT WAS ALL I NEEDED TO TELL A STORY THAT TOOK PLACE UNDER THE SEA, BASED ON A CLOUD THAT WAS JUST ABOVE ME.

"He stepped outside and looked up at the stars swimming in schools through the wind-driven clouds."

JOHN STEINBECK

63

Partial Sketches

WHEN I FIRST PUBLISHED MY CLOUD SKETCHES ON
A BLOG I CREATED ESPECIALLY FOR THIS PROJECT, I HEARD
FROM A LOT OF PEOPLE WHO SAID, "I'VE THOUGHT ABOUT
DOING THE SAME!" I ALWAYS TELL THEM THE SAME THING:
"THEN WHY DIDN'T YOU DO IT?" I BELIEVE EVERYONE CAN
DO THIS BECAUSE ALL YOU NEED IS A PICTURE OF A CLOUD,
SOMETHING TO DRAW WITH, AND YOUR IMAGINATION.

LET'S MAKE A LITTLE EXERCISE THAT I'M SURE WILL
MAKE YOU WANT TO TURN CLOUDS INTO ILLUSTRATIONS,
TOO. I SELECTED TEN CLOUDS AND STARTED ILLUSTRATING
THEM, BUT I DIDN'T FINISH THEM BECAUSE I WANT YOU
TO DO IT. I KNOW YOU CAN!

AZTEC SERPENT HEAD CLOUD

YOU MIGHT THINK THAT THIS ILLUSTRATION IS ALMOST DONE, BUT I CAN ASSURE YOU THERE'S STILL A LOT TO DO. I MADE THE MOST IMPORTANT LINES SO YOU CAN CLEARLY IDENTIFY THE AZTEC SERPENT HEAD, BUT HALF OF THE FEATHERS ARE NOT DRAWN, AND THE CONNECTIONS BETWEEN THEM AND THE FEATHERS ON ITS HEAD ARE MISSING. I ALSO MADE A FEW CREVICES, BUT I'M SURE YOU CAN ADD A FEW MORE, WHICH WILL HELP IT LOOK EVEN MORE REALISTIC. AS YOU'VE SEEN ON SOME OF MY OTHER CLOUDS, I PLAY A LOT WITH LIGHT AND SHADING. AND THIS ILLUSTRATION HAS ALMOST NO SHADING AT ALL. I STARTED ADDING A FEW SHADOWS FROM LEFT TO RIGHT, BUT ONLY ENOUGH TO GIVE A REFERENCE OF HOW IT SHOULD BE DONE. HAVE FUN WITH IT—THERE A LOT OF DETAILS THAT STILL CAN BE ADDED!

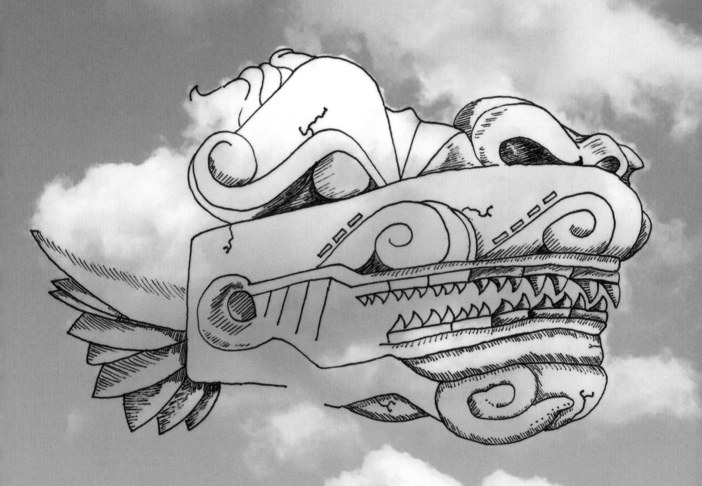

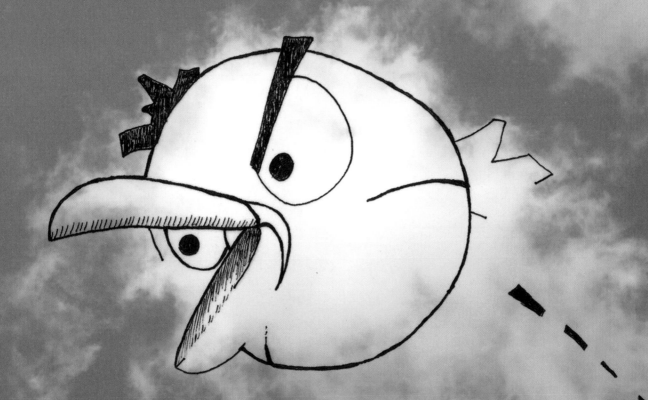

GREEN ANGRY BIRD CLOUD

I BASED THIS ILLUSTRATION ON ONE OF THE *ANGRY BIRDS* CHARACTERS FROM THE FAMOUS VIDEO GAME BECAUSE I NEEDED SOMETHING FAIRLY SIMPLE TO SKETCH IN THE SHAPE OF THIS CLOUD. THIS IS AN ILLUSTRATION THAT'S EASY TO FINISH; I BELIEVE IT CAN HELP YOU FEEL MORE SELF-CONFIDENT ABOUT TURNING CLOUDS INTO ILLUSTRATIONS. YOU CAN EVEN PAINT IT GREEN IF YOU WANT TO!

"The road of life is filled with sunshine and clouds, black and white, triumphs and tragedies. As we continue down the road, we decide which things we bring with us, and which we leave in the rear-view mirror."

JULIE-ANNE

GRANDPA CLOUD

MOST OF THE TIME, WHEN I LOOK FOR A CREATURE HIDDEN IN THE SHAPE OF A CLOUD, THE FIRST THING I SEARCH FOR ARE THE EYES: ONCE I FIND THEM, MY IMAGINATION STARTS WORKING AND CREATES THE REST OF THE CREATURE AROUND THEM. THE EYES SAY A LOT AND, DEPENDING ON THE WAY WE DRAW THEM, CAN SUGGEST THE PERSONALITY OF OUR CREATION. MAYBE THAT'S WHY I DIDN'T PAINT THEM IN THE ILLUSTRATION OF THE CLOUD WITH THE SHAPE OF MY GRANDPA: I DREW HIS MOUSTACHE, THE PIPE HE SMOKED, AND EVEN HIS BIG EYEBROWS. NOW, IT'S YOUR TURN TO FINISH THIS SKETCH: YOU CAN GIVE HIM BACK HIS EYES AND ALSO IMAGINE HIS HAIR, DISHEVELED BY THE WIND.

"The air up there in the clouds is very pure and fine, bracing and delicious. And why shouldn't it be? It is the same the angels breathe."

MARK TWAIN

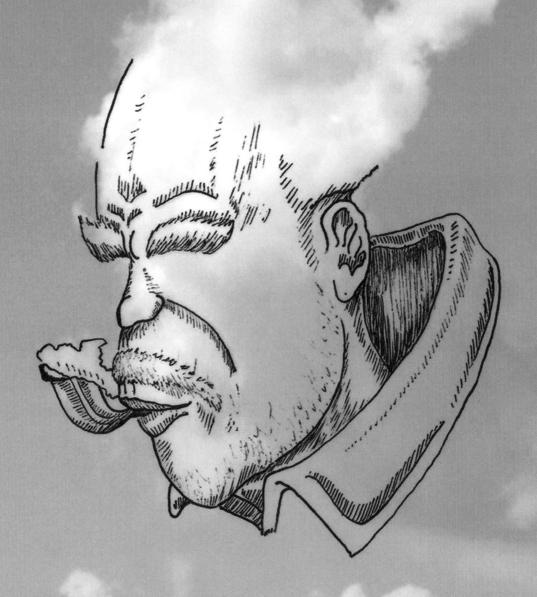

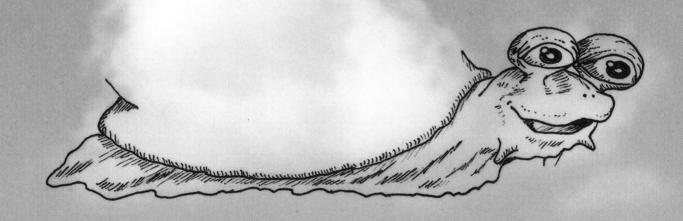

"I can be jubilant one moment and pensive the next. And a cloud could go by and make that happen."

BOB DYLAN

SNAIL CLOUD

I DON'T KNOW IF IT WAS BECAUSE THE WIND WASN'T MOVING IT AT ALL, BUT THIS CLOUD LOOKED LIKE A LAND SNAIL FROM THE SECOND I PUT MY EYES ON IT. I DREW ITS FACE AND ALSO ITS BIG EYES, BUT I DECIDED TO GIVE YOU THE CHANCE TO ILLUSTRATE THE COILED SHELL. IF YOU LOOK DIRECTLY AT THE CLOUD, YOU'LL SEE THAT ITS SHADING WILL GUIDE YOU, AS IF IT WERE THE SHELL'S WHORL. I KNOW YOU CAN DO IT!

OUT OF THE BLUE

CUMULUS CLOUDS ARE PUFFY, LIKE COTTON FLOATING IN THE SKY.

COAT OF ARMS CLOUD

WHEN I PHOTOGRAPHED THIS CLOUD, I KNEW I WOULD MAKE SOMETHING COOL, BECAUSE IT HAD THE SHAPE OF A SHIELD AND AN IRREGULAR OUTLINE THAT WOULD ALLOW ME TO DECORATE IT WITH WHATEVER I WANTED, TURNING IT INTO MY OWN COAT-OF-ARMS CLOUD SKETCH. AS YOU CAN SEE, THE DECORATION OF THE SHIELD IS UNFINISHED AND SO IS THE RIGHT-HAND SIDE OF THE ILLUSTRATION. LOOK AT THE OTHER SIDE AND USE IT AS REFERENCE TO CREATE YOUR OWN SHIELD'S LEAVES AND FEATHERS.

OUT OF THE BLUE

CLOUDS ARE FORMED WHEN WATER ON EARTH EVAPORATES INTO THE SKY AND CONDENSES HIGH UP IN THE COOLER AIR.

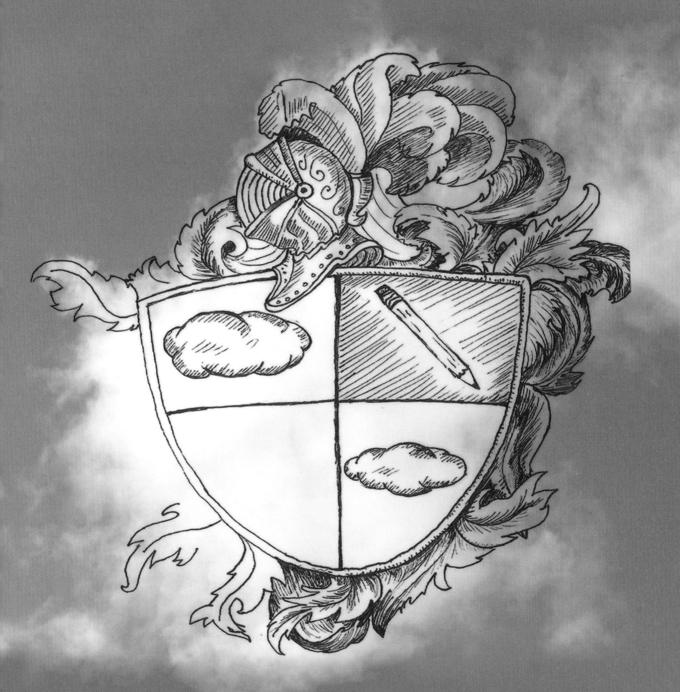

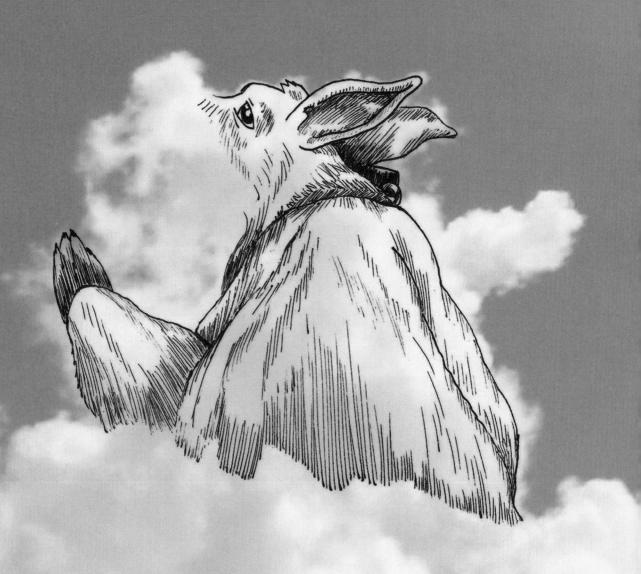

DOG SCRATCHING CLOUD

WHEN I SAW THIS CLOUD, I KNEW THAT I WAS GOING TO DRAW SOMETHING USING ONLY PART OF IT. I DIDN'T USE IT ALL BECAUSE I WANTED TO CREATE SOMETHING THAT WAS OVER THE CLOUD. THIS IS NOT A RELATIVE OF ROCK THE WEIRD DOG CLOUD (SEE PAGE 26). WHAT YOU HAVE HERE IS A DIFFERENT DOG THAT'S SCRATCHING HIS SNOUT (OR AT LEAST TRYING TO), BUT HE CAN'T DO IT BECAUSE IT DOESN'T EXIST YET! YOU CAN HELP HIM RELIEVE HIS ITCHING: USE A PENCIL AND LET YOUR IMAGINATION SHOW YOU HOW TO DRAW HIS NOSE AND A TONGUE COMING OUT OF HIS OPEN MOUTH.

"There's a bright spot in every dark cloud."

BRUCE BERESFORD

SEAHORSE CLOUD

THE CLOUD COULD HAVE BEEN NOTHING BUT A SMALL SEAHORSE: I SAW IT UP THERE, SWIMMING UPRIGHT, WITH ITS CORONET–SHAPED HEAD, USING ITS DORSAL FIN AND ITS PECTORAL FINS TO MOVE THROUGH THE AIR, AND I AUTOMATICALLY KNEW WHAT TO DO WITH IT.

YOU'LL SEE THAT ITS SNOUT AND ITS CHEST ARE NOT FINISHED. ADD SOME SHADING TO SHAPE IT AND, ONCE YOU'VE DONE THAT, GO FOR THE TAIL; THIS LITTLE CREATURE NEEDS IT IN ORDER TO HOLD A FEMALE SEAHORSE WHILE THEY STAND SIDE BY SIDE AND WHEEL AROUND IN UNISON, WHICH IS THE WAY THEY START THEIR REPRODUCTION PROCESS.

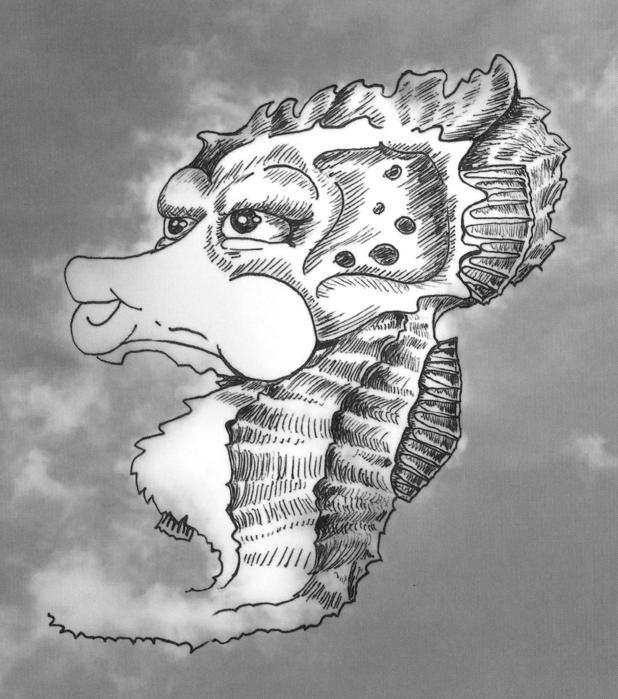

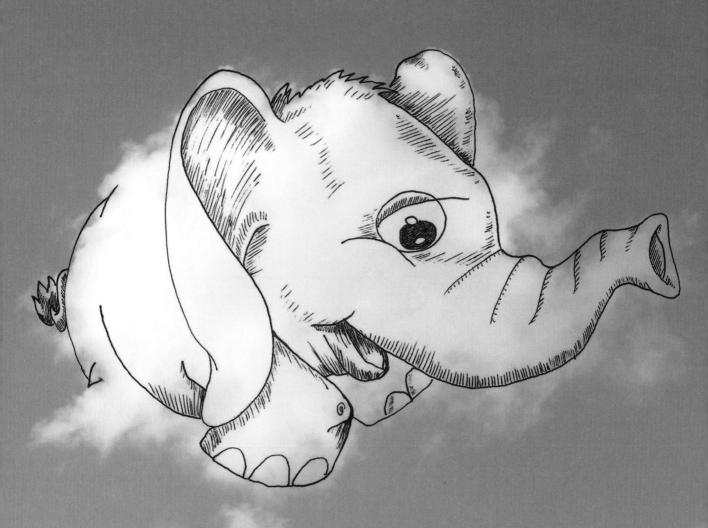

ELEPHANT CLOUD

WHAT GAVE ME THE IDEA TO TURN THIS CLOUD INTO AN ELEPHANT WAS ITS TRUNK. I STARTED FROM THERE, AND THEN I KEPT DRAWING THE REST. YOU CAN SEE ITS BIG EYES, BOTH OF ITS BIG EARS, AND ITS SMALL TAIL, BUT ITS BACK IS INCOMPLETE AND THE HIND LEGS ARE STILL MISSING.

YOU CAN ALSO USE THIS UNFINISHED CLOUD SKETCH TO PRACTICE WITH THE SHADING AND LIGHT OF AN ILLUSTRATION BECAUSE, AS WE ALL KNOW, ELEPHANTS ARE MOSTLY GRAY (UNLESS YOU WANT TO KEEP IT AS A RARE ALBINO ELEPHANT, OF COURSE).

OUT OF THE BLUE

NIMBUS CLOUDS MEAN RAIN OR SNOW IS COMING; NIMBUS IS FROM THE LATIN FOR "RAIN BEARING."

FINGERLESS GLOVE CLOUD

FINDING A CLOUD THAT REMINDED ME OF A HAND WASN'T EASY. I GUESS I WAS LUCKY THAT DAY. THE CLOUD LOOKED LIKE A HAND THAT WAS FEELING THE WIND WHILE IT WAS MOVING THROUGH THE SKY. BUT FOR ME, TURNING THAT CLOUD INTO A HAND WAS NOT GOING TO BE ENOUGH; THAT'S WHY I DECIDED TO MAKE IT WEAR A FINGERLESS GLOVE, AS IF IT WERE THE HAND OF A MAN WHO WAS RIDING ONE OF THOSE HEAVYWEIGHT MOTORCYCLES DESIGNED FOR LONG JOURNEYS. I DIDN'T WANT THE GLOVE TO BE COMPLETELY BLACK BECAUSE THAT WOULD'VE COVERED ALMOST ALL THE CLOUD.

NOW IT'S YOUR TURN TO FINISH HIS FINGERS. I ILLUSTRATED ONLY HIS THUMB AND INDEX FINGER BECAUSE I WANTED TO GIVE YOU A REFERENCE, SO YOU CAN WORK ON HIS MIDDLE, RING, AND PINKIE FINGERS IN ORDER TO MAKE THAT HAND LOOK LIKE THE HAND OF A BIKER!

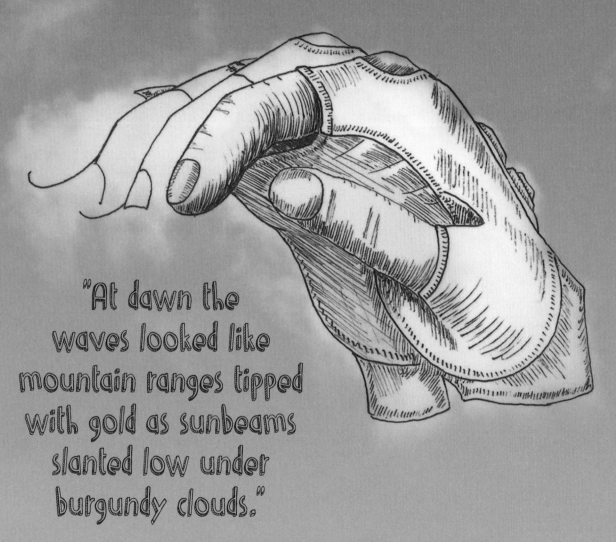

"At dawn the waves looked like mountain ranges tipped with gold as sunbeams slanted low under burgundy clouds."

DAVID MITCHELL

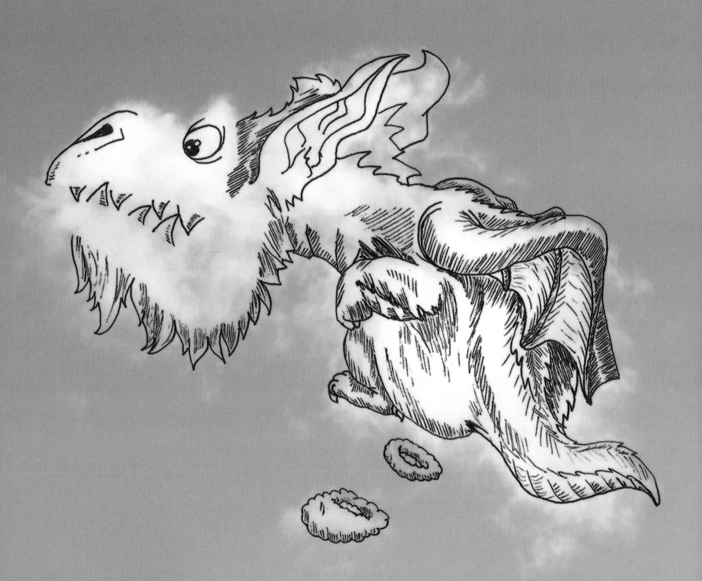

LITTLE DRAGON CLOUD

THE REASON WHY I PUT MY LITTLE DRAGON AT THE END OF THIS LIST OF PARTIALLY SKETCHED CLOUDS IS BECAUSE I WANTED YOU TO HAVE FUN WITH IT. YOU CAN SEE ITS EYE, BUT IT HAS NO EXPRESSION AT ALL, AND EYEBROWS WILL HELP GIVE IT ONE. YOU HAVE ITS TEETH, ITS NOSE, AND EVEN ITS LONG BEARD, BUT THE REST OF ITS SNOUT IS MISSING, AND SO IS ITS TONGUE. YOU CAN ALSO PAINT ITS EARS BY CREATING DIFFERENT SHADES TO MAKE THEM LOOK THE WAY YOU WANT (LOOK AT ITS LITTLE WINGS FOR REFERENCE). I TOOK CARE OF ITS TAIL, WINGS, LEGS, AND BODY, BUT NOW, FROM THE NECK ON, IT'S ALL YOURS.

"Try to be a rainbow in someone's cloud."

MAYA ANGELOU

Guided Sketches

Now let's do things differently:
I'll pick the clouds, and we'll let your
imagination do the rest.

HERE'S A LITTLE SELECTION OF CLOUDS I'VE CHOSEN ESPECIALLY FOR YOU. NOW IT'S YOUR TURN TO TURN A CLOUD INTO WHATEVER COMES TO YOUR MIND WHEN YOU LOOK AT IT. LET YOUR MIND'S EYE LEAD YOUR HAND AND CREATE YOUR OWN CLOUD SKETCHES.

I'LL GIVE SOME SUGGESTIONS OF WHAT THOSE DRAWINGS CAN BE (AT LEAST FROM MY PERSPECTIVE), BUT IT'S UP TO YOU TO MAKE THE FINAL DECISION AND ILLUSTRATE THEM THE WAY YOU WANT. IT'S VERY IMPORTANT THAT, WHILE YOU DO THIS, YOU DON'T FORGET TO HAVE FUN!

"I think the most heavenly food is fluffy white clouds."

JAROD KINTZ

CLOUD #01

TO ME, THIS LOOKS LIKE A BIG PELICAN WITH A HUGE DIP—NET BEAK AND SMALL WINGS. I COULD SEE IT ABOVE US, WITH ITS WINGS FOLDED, AS IF IT WERE FLYING, THANKS TO THE IMPETUS OF ITS LAST FLUTTER. IF YOU LOOK AT THE TREE BELOW THE CLOUD, YOU'LL SEE THAT IT COULD BE A LITTLE NEST WITH ONE BABY PELICAN WAITING FOR ITS MUMMY.

EVEN THOUGH THIS IS ONE OF THE FIRST CLOUDS I PHOTOGRAPHED, I DON'T KNOW WHY I NEVER USED IT UNTIL NOW. MAYBE IT'S BECAUSE IT WAS A CLOUD THAT I SAVED FOR YOU, UNCONSCIOUSLY, SO YOU CAN HAVE FUN WITH IT, CREATING A BEAUTIFUL FAMILY MOMENT FOR THAT PELICAN CLOUD.

OUT OF THE BLUE

MOST CLOUDS FORM IN THE TROPOSPHERE (THE LOWEST PART OF EARTH'S ATMOSPHERE), BUT OCCASIONALLY THEY ARE OBSERVED AS HIGH AS THE STRATOSPHERE OR MESOSPHERE.

CLOUD #02

I'VE USED ONE OF THESE CLOUDS (THE ONE ON THE LEFT) TO CREATE MY GENIE CLOUD (SEE PAGE 53), BUT EVERY TIME I LOOK AT THESE TWO CLOUDS TOGETHER, I CAN'T HELP BUT SEE A MAN WITH CURLED HAIR AND A BUSHY MOUSTACHE WHO IS MAKING EYE CONTACT WITH AN ELEPHANT–FISH (WHICH IS, AS ITS NAME SAYS, HALF ELEPHANT AND HALF FISH). I KNOW IT'S AN IMPOSSIBLE SITUATION, BUT IT'S ALSO A FUNNY ONE. IF YOU LOOK FOR DETAILS, YOU MAY EVEN BE ABLE TO SEE THAT THE ELEPHANT–FISH HAS ITS TRUNK UP, AS IF IT WERE SAYING "HI!"

"I want to read every book that's written, hear every song that was sung. I want to gaze at every cloud and hold the zing of each fruit on my tongue."

SANOBER KHAN

CLOUD #03

THERE ARE MANY WAYS TO ILLUSTRATE THESE CLOUDS. FIRST OF ALL, REMEMBER THAT YOU DON'T ALWAYS HAVE TO USE THEM ALL. SOMETIMES, YOU CAN ONLY USE ONE CLOUD, AND THERE ARE OTHER TIMES WHEN YOU MIGHT NEED MORE THAN ONE CLOUD TO TELL A STORY.

WHEN I TOOK THIS PHOTOGRAPH, I WAS FOCUSED ONLY ON THE BIG CLOUD (THE ONE ON THE RIGHT) BECAUSE IT GAVE ME THE IDEA TO ILLUSTRATE IT AS THE HEAD OF A FUNNY CRANE WITH AN AWFUL HAIRDO—A FRIGHTENING PONYTAIL SURROUNDED BY FEATHERS POINTING IN ALL DIRECTIONS. THAT CLOUD CAN ALSO BE SKETCHED AS THE HEAD OF A DOG OR EVEN AN EAGLE SPREADING IT WINGS AS IF IT WERE ABOUT TO HAUNT THE OTHER CLOUD, WHICH CAN ALSO LOOK LIKE SOME KIND OF FISH AT THE WRONG TIME AND PLACE.

CLOUD #04

I HAD A DILEMMA WITH THIS CLOUD AT THE MOMENT I SAW IT AND PHOTOGRAPHED IT. I KNOW IT LOOKS LIKE A BIRD OR ANY OTHER FLYING ANIMAL THAT YOU CAN IMAGINE (REMEMBER, IT CAN BE REAL, MYTHOLOGICAL, OR FANTASTIC), BUT I BELIEVE I NEVER ILLUSTRATED IT BECAUSE I COULDN'T DECIDE WHICH DIRECTION TO GO: THIS CLOUD CREATURE HAS TWO POTENTIAL HEADS, AND THE ONE YOU USE WILL DETERMINE THE REST OF THIS CREATURE'S SHAPE (UNLESS YOU DARE TO DRAW A CREATURE WITH TWO HEADS). FOR ALL THIS, I PREFER TO LET YOU CHOOSE AND HAVE A WONDERFUL TIME DRAWING IT!

OUT OF THE BLUE

THERE ARE MANY COMBINATIONS OF THE MAIN CLOUD TYPES, INCLUDING STRATOCUMULUS, ALTOSTRATUS, ALTOCUMULUS, NIMBOSTRATUS, CUMULONIMBUS, AND CIRROCUMULUS.

CLOUD #05

THE THIN LINE YOU SEE BEHIND THIS CLOUD WAS MADE BY AN AIRPLANE. THE TRAIL PLANES LEAVE IN THE SKY WHEN THEY PASS BY IS CALLED A *CONTRAIL*. IT WAS WHAT MADE ME PAY ATTENTION TO THIS CLOUD THAT LOOKS LIKE A WHITE SWAN, PEACEFULLY RESTING ON A LAKE. ANOTHER WAY TO THINK OF THIS CLOUD (AND A MORE BIZARRE ONE) IS AS *ALIEN'S* FAMOUS "CHEST BURSTER," WITH ITS HORRIBLE MOUTH AND ITS LITTLE BODY, CRAWLING ON THE SKY, LOOKING FOR ITS NEXT VICTIM.

"'And when I fall in love,'" I began, 'I will build a mountain to touch the sky. Then, my lover and I will have the best of both worlds, reality firmly under our feet, while we have our heads in the clouds with our illusions still intact.'"

V. C. ANDREWS

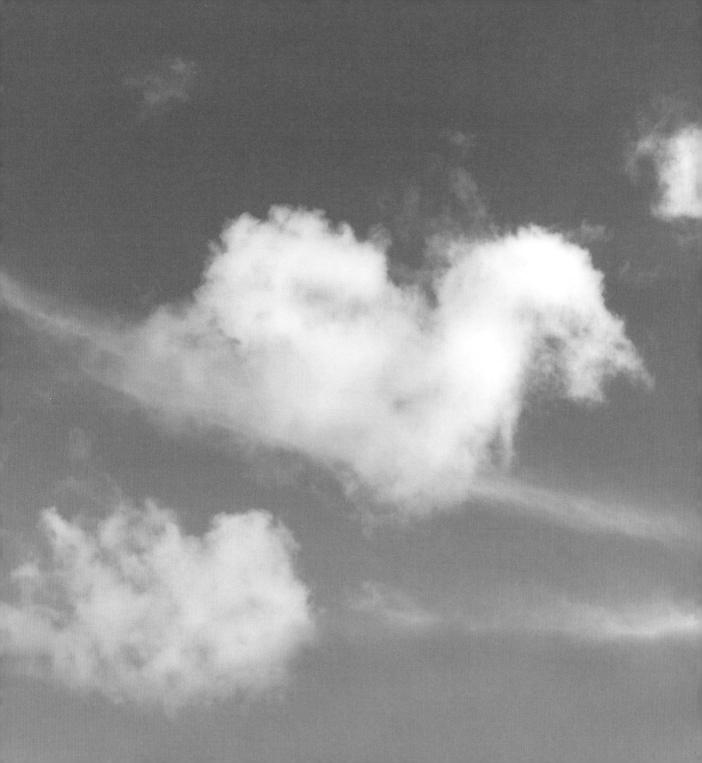

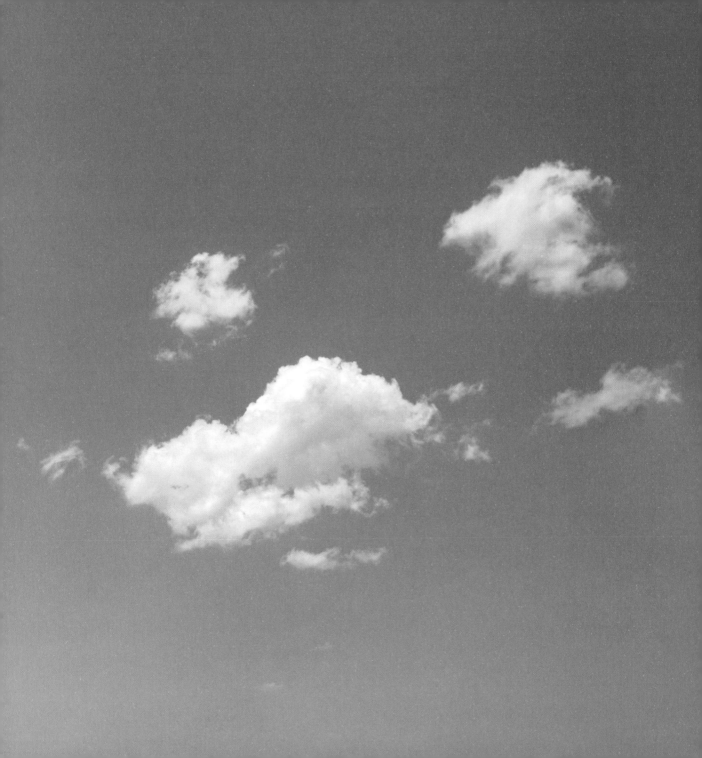

CLOUD #06

EVERY TIME I PHOTOGRAPH A CLOUD, I TRY TO DO IT WITH AT LEAST ONE IDEA IN MIND. BUT SOMETIMES, AFTER PRINTING IT AND PREPARING TO TURN IT INTO AN ILLUSTRATION, I REALIZE THAT A CLOUD'S DIMENSIONS ARE NOT THE WAY I REMEMBERED THEM, AND I HAVE TO COME UP WITH A DIFFERENT SOLUTION. ONE OF THE TRICKS THAT ALWAYS WORKS FOR ME IS TO MAKE MY IDEA "YOUNGER," FOR EXAMPLE, DRAWING BABY CREATURES.

IN THIS CASE, WHEN I TOOK THIS PICTURE, I THOUGHT IT COULD BE SOME KIND OF DRAGON OR EVEN A PTERODACTYL, BUT EVIDENTLY I WAS JUST THINKING ABOUT ITS HEAD BECAUSE THERE IS ALMOST NO BODY AT ALL; THAT'S WHY I SUGGEST YOU USE THIS CLOUD TO CREATE A BABY VERSION OF A DRAGON OR PTERODACTYL. YOU CAN DRAW YOUR CREATURE IN A LITTLE DIAPER TO MAKE IT LOOK FUNNIER. ON THE OTHER HAND, IF YOU PREFER TO LOOK FOR SOMETHING COMPLETELY NEW, YOU CAN ALSO DRAW A CROUCHING GARGOYLE THAT IS UNFOLDING ITS WINGS.

CLOUD #07

I LOVE THIS KIND OF CLOUD BECAUSE THERE ARE A LOT OF THINGS YOU CAN DO WITH IT: YOU CAN USE THE WHOLE CLOUD OR JUST A PART OF IT. THERE'S A PART OF THE CLOUD (LOCATED RIGHT IN THE CENTER OF THE IMAGE) THAT LOOKS LIKE A HEAD AND, ABOVE IT, A LITTLE CLOUD THAT COULD BE ITS WIG OR A GIANT RING THAT COULD SYMBOLIZE ITS AURA.

IT'S UP TO YOU TO TURN THIS CLOUD INTO ANYTHING YOU LIKE, FROM A FUNNY LITTLE CREATURE—LIKE A PIGEON WITH A WIG, FOR EXAMPLE—TO A HUGE SEA CREATURE FROM HEAVEN, A TERRIFYING SNAKE FROM THE AMAZON, OR EVEN A BIG DRAGON, LIKE THE ONES THE CHINESE USE FOR THEIR NEW YEAR'S CELEBRATIONS.

OUT OF THE BLUE

IT TAKES ANYWHERE FROM A FEW MINUTES TO AN HOUR FOR A CLOUD TO FORM.

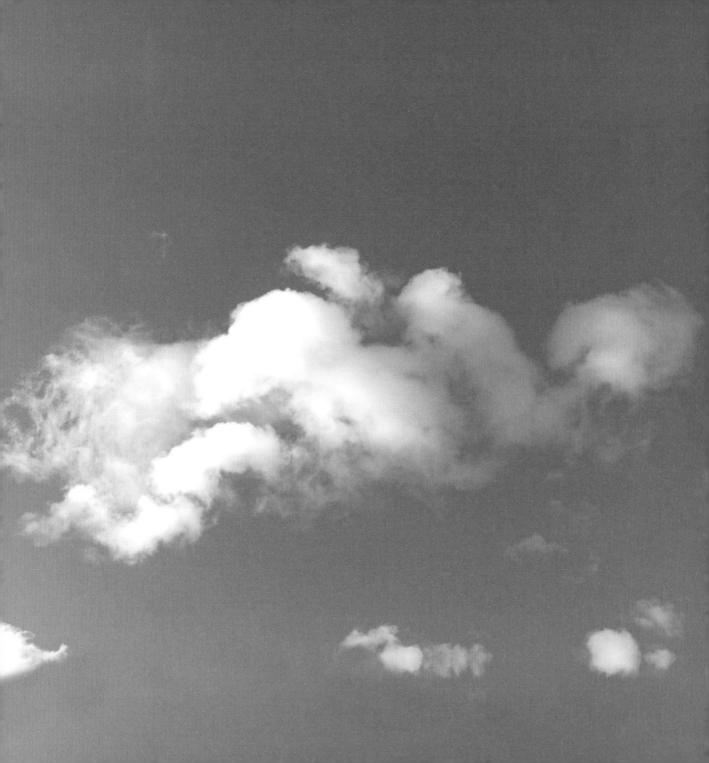

CLOUD #08

IF YOU LOOK AT THIS CLOUD, YOU'LL SEE THAT IT HAS TWO DIFFERENT "DENSITIES," WITH A MORE SOLID MIDDLE AND TWO PARTS AT THE SIDES THAT SEEM LIKE THEY'RE FADING. YOU CAN USE THE WHOLE CLOUD AND TURN IT INTO SOME KIND OF FAT BIRD THAT'S REALLY MAKING AN EFFORT TO FLY, OR YOU CAN USE ONLY WHAT WOULD'VE BEEN THE FAT BIRD'S BODY AND TURN IT INTO A FUNNY DOG WITH SMALL FEET, BIG EYES, AND ITS TONGUE OUT. THESE ARE JUST TWO EXAMPLES I IMAGINED, BUT I'M SURE YOU CAN COME UP WITH MORE IDEAS INSPIRED BY THE SHAPE AND DIFFERENT DENSITIES OF THIS CLOUD.

"Love is a Heaven Cake, with clouds for icing. If there are two pieces left, I guess I can have seconds."

JAROD KINTZ

OUT OF THE BLUE

FLAT AND FEATURELESS, STRATUS CLOUDS APPEAR AS LAYERED SHEETS.

CLOUD #09

THE GOOD THING ABOUT THIS KIND OF CLOUD IS THAT YOU'RE NOT SURE WHAT IT LOOKS LIKE AT FIRST SIGHT. THAT'S OK. I CAN ASSURE THE MORE YOU LOOK AT IT, THE MORE IDEAS THAT WILL APPEAR IN YOUR MIND.

HERE ARE A FEW IDEAS I HAD WHILE I WAS LOOKING AT THIS PARTICULAR CLOUD: THE FIRST THING I SAW WAS A LOCUST, WHICH I THOUGHT WAS MAYBE JUMPING FROM ONE PLACE TO THE OTHER. BUT, RIGHT AFTER THAT, I THOUGHT ABOUT A PIGEON THAT WAS DESPERATELY FLYING AWAY FROM SOMEWHERE OR SOMEONE. I KNOW THAT IF I KEEP LOOKING AT IT, I COULD COME UP WITH MORE IDEAS, BUT NOW IT'S YOUR TURN TO HAVE FUN WITH THIS CLOUD.

OUT OF THE BLUE

THE ICE AND WATER IN CLOUDS SCATTER AND REFLECT THE SUN'S LIGHT, WHICH CAUSES CLOUDS TO APPEAR WHITE.

CLOUD #10

SOMETIMES, I ENJOY CLEARING MY MIND AND SIMPLY PHOTOGRAPHING CLOUDS JUST FOR FUN. THESE CLOUDS ARE THE ONES THAT SURPRISE ME THE MOST BECAUSE, WHEN I FINALLY PRINT THEM AND TAKE A LOOK, I FEEL THE SAME WAY YOU MUST BE FEELING NOW: THE FIRST TIME YOU SEE A CLOUD PRINTED ON A PAPER AND THE MIND STARTS LOOKING FOR SHAPES AND COMES UP WITH DIFFERENT IDEAS IS A MAGICAL MOMENT FOR ME.

NOW THAT I'M LOOKING AT THIS CLOUD, WHAT COMES TO MY MIND IS THE IMAGE OF AN OCTOPUS WITH SMALL TENTACLES AND A BIG HEAD; IT CAN ALSO BE A MOUSE WITH A HUGE SOMBRERO OR EVEN A JELLYFISH SWIMMING THROUGH THE SKY. YOU CAN CHOOSE ANY OF THESE OPTIONS OR FIND YOUR OWN CREATURE, INSPIRED BY THIS LITTLE CLOUD. HAVE FUN!

Free Sketches

I'll supply the clouds and your
imagination does the rest!

NOW IT'S YOUR TURN. FOLLOWING IS AN ASSORTMENT
OF CLOUDS ESPECIALLY FOR YOU, AS WELL AS SPACE
TO PASTE IN PICTURES OF CLOUDS FROM YOUR OWN TRAVELS.
LET YOUR IMAGINATION LEAD YOUR HAND AND
CREATE YOUR OWN CLOUD SKETCHES.

"The sky is that beautiful old parchment in which
the sun and the moon keep their diary."

ALFRED KREYMBORG

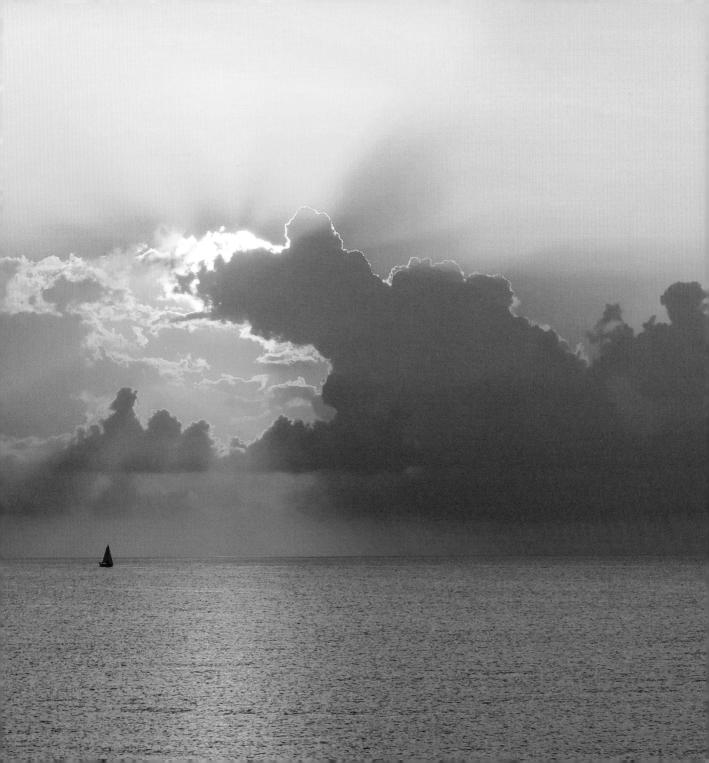

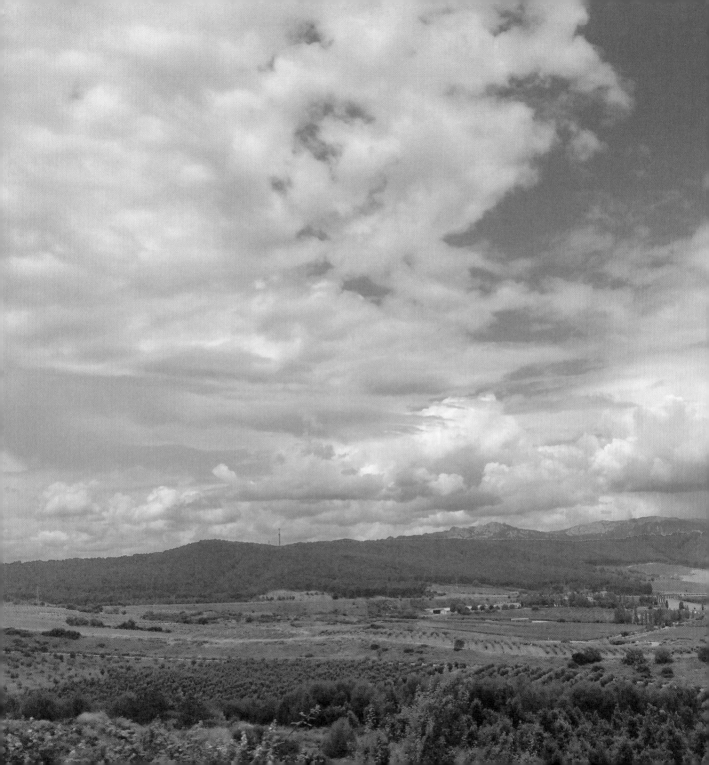

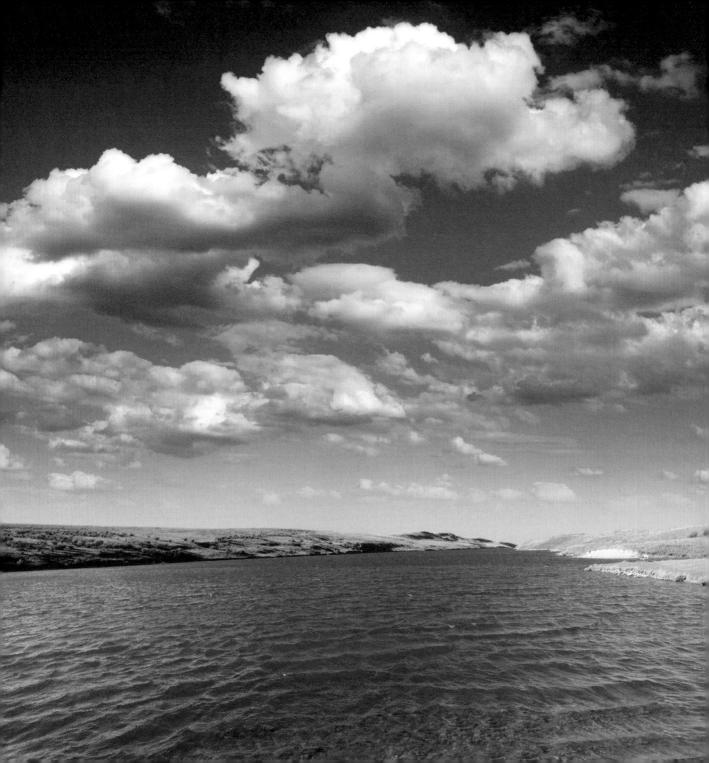

INDEX

ABOUT THE AUTHOR

MARTÍN DIEGO FEIJOÓ GÓMEZ (NOVEMBER 23, 1981—JANUARY 25, 2015) WAS AN ARGENTINIAN CREATIVE BORN IN THE CITY OF HAEDO, IN BUENOS AIRES PROVINCE. SON OF BOTH A SPANISH FATHER AND MOTHER, HE STARTED SHOWING HIS CREATIVITY FROM AN EARLY AGE IN LITERATURE AND DRAWING CLASSES. HIS PASSION FOR COMICS AND TATTOOS MARKED HIS EARLY WORKS UNTIL SCIENCE FICTION SPARKED HIS LOVE FOR BOOKS, TURNING HIM INTO A TIRELESS GOOD-STORY SEEKER. WHEN HE WAS A TEENAGER HE BECAME PART OF THE LOCAL GRAFFITI CIRCLE FOR SEVERAL YEARS UNTIL FATE LED HIM TO THE WORLD OF ADVERTISING. HE ATTENDED FUNDACIÓN DE ALTOS ESTUDIOS EN CIENCIAS COMERCIALES (FAECC), WHERE HE STUDIED ADVERTISING AND STRATEGIC COMMUNICATION. HE WORKED AS A COPYWRITER IN DIFFERENT ADVERTISING AGENCIES IN BUENOS AIRES UNTIL HE MOVED TO MADRID AT THE AGE OF TWENTY-FOUR.

WHILE HIS WORK HAS BEEN AWARDED SOME OF THE MOST PRESTIGIOUS ADVERTISING ACCOLADES IN THE WORLD, MARTÍN FEIJOÓ CONTINUED DEVELOPING SEVERAL PERSONAL PROJECTS WHERE HE GAVE FREE REIN TO HIS IMAGINATION. SOME OF HIS WORK HAS BEEN PUBLISHED IN THE BOOK *STORIES THAT SELL NOTHING: WHAT ADVERTISING CREATIVES WRITE WHEN THEY'RE NOT THINKING ON BRANDS*, AMONG OTHER PRESTIGIOUS ARGENTINIAN PROFESSIONALS. HE ALSO PUBLISHED *TWITTALES*, A COLLECTION OF SHORT TALES THAT CAN BE SHARED ON TWITTER. *CLOUD SKETCHING* IS A PROJECT THAT WAS BORN IN MEXICO, CAME TO LIFE IN MADRID, AND HAS BECOME THE BOOK THAT'S BEING PUBLISHED ALL OVER THE WORLD.

EPILOGUE

Each cloud that passes over us will carry your memory.

YOUR PARENTS

TINCHO WAS LIGHT, GOODNESS, AND HONESTY. IN JUST ONE GLANCE YOU KNEW HE WAS A SPECIAL PERSON, CREATIVE, INTELLIGENT AND POSITIVE. FROM NOW ON, EACH AND EVERY ONE OF US WHO LOVE HIM WILL BE SEARCHING FOR HIS SOUL WITHIN THE CLOUDS TO NEVER, EVER FORGET HIM.

THANK YOU MY LOVE, FOR EIGHT YEARS OF TRUE HAPPINESS.

FOREVER YOURS, LETI

Cada nube que pase nos traerá tu recuerdo.

TUS PADRES

TINCHO ERA LUZ, BONDAD Y HONESTIDAD. SÓLO HACÍA FALTA CRUZARSE CON SU MIRADA PARA SABER QUE ERA UNA PERSONA ESPECIAL, CREATIVA, INTELIGENTE Y POSITIVA. A PARTIR DE AHORA, TODAS LAS PERSONAS QUE LE AMAMOS BUSCAREMOS SU ALMA EN LAS NUBES PARA NO OLVIDARLE JAMÁS.

GRACIAS MI VIDA POR 8 AÑOS DE AUTÉNTICA FELICIDAD.

POR SIEMPRE TUYA, LETI

ALSO AVAILABLE

The Art of Urban Sketching
978—1—59253—725—9

20 Ways to Draw a Star
978—1—63159—059—7

ll-LIST-ration
978—1—63159—094—8

**100 Things to Draw
with a Triangle**
978—1—63159—100—6